TALES of ALABAMA

Kelly Kazek

illustrations by
Kyle McQueen

The History PRESS

Published by The History Press
Charleston, SC 29403
www.historypress.net

Copyright © 2010 by Kelly Kazek
All rights reserved

First published 2010
Second printing 2012
Third printing 2013

Manufactured in the United States
ISBN 978.1.60949.097.3

Library of Congress Cataloging-in-Publication Data
Kazek, Kelly.
Forgotten tales of Alabama / Kelly Kazek.
p. cm.
ISBN 978-1-60949-097-3
1. Alabama--History--Anecdotes. 2. Alabama--Social life and
customs--Anecdotes. 3. Alabama--Biography--Anecdotes. 4.
Curiosities and wonders--Alabama--Anecdotes. I. Title.
F326.6.K38 2010
976.1--dc22
2010033156

Notice: The information in this book is true and complete to the best of our knowledge. It is offered without guarantee on the part of the author or The History Press. The author and The History Press disclaim all liability in connection with the use of this book.

All rights reserved. No part of this book may be reproduced or transmitted in any form whatsoever without prior written permission from the publisher except in the case of brief quotations embodied in critical articles and reviews.

To the one person destined to love weirdness even more than I do: my daughter, Shannon. Thanks for going along for the ride.

Contents

Preface	7
Acknowledgements	9
Part I. Colorful Characters	11
Part II. Strange Sites	55
Part III. Intriguing Incidents	89
Part IV. Tombstone Tales	125
Part V. Curious Creatures and Odd Occurrences	155
About the Author	191

Preface

Like most Southerners, we Alabamians take pride in our eccentrics. After all, it is the unusual people and their quirks that are the subjects of most southern tales.

During my more than two decades as a journalist, I have been collecting such stories and was fortunate to have the opportunity to compile them into this book to share with others who are curious about this state. Alabama is not only rich in history, it is also a beautiful state that—from its mountains to its beaches—is filled with natural wonders. Great stories can be found everywhere—many more than can be contained in one volume. I tried to include those you may not have heard.

Tales on these pages include those about:

- Colorful Characters such as the bitter Confederate who created a monument to John Wilkes Booth, the

Birmingham Batman who rescued stranded motorists and "The Giggling Granny," Nannie Doss, who murdered four of her husbands;
- Strange Sites, including Huntsville's "Eggbeater Jesus," the tree that owns itself and the former location of the world's largest Nehi bottle;
- Intriguing Incidents such as the 1902 church panic, the Birmingham axe murder spree and the moonshine murder mystery;
- Tombstone Tales about the 194 mystery graves, the woman whose headstone proclaims she was "Murdered by Her Husband" and the man buried in two different cemeteries;
- Curious Creatures and Odd Occurrences, including supernatural tales of the wolf woman of Mobile, UFOs and the white thing, plus stories about critters such as the world's oldest chicken, the first monkey in space and the battle of the monster pigs.

In addition, many people may not realize that Alabama has connections to some major national events, such as the Manson family murders and the disappearance of the USS *Cyclops* in the Bermuda Triangle.

I hope you enjoy reading the book as much as I enjoyed doing the research.

You've gotta love a state that is home to the man who blew the world's largest bubble gum bubble. Am I right?

Acknowledgements

Many thanks to those who helped with research for this book: Ann B. Pearson, Margaret Ernest, Jim Harrison with First Baptist Church of Huntsville, Eleanor Drake, Kerry Reid with Clarke County Museum, Chris Beverly, Karen Bullard, Dorothy Nichols, Kaye Hillis of the Florence Historical Society, George Meares and Ginger Cobl of Harrison Brothers Hardware, Steve Croomes, Barbara Clark with the Hayden Cemetery board, Michelle Tanner of the *Decatur Daily*, Christie Lovvorn of Mobile Archives, Sylvia Beasley Clarke, Roberta Childs, Limestone County Archives, Morgan County Archives, Vulcan Park and Museum and the wonderful staff of The History Press.

Part I

Colorful Characters

THE ONLY KNOWN MEMORIAL TO JOHN WILKES BOOTH

Fifty-six years after the end of the Civil War, officials in the town of Troy, Alabama, were being embarrassed by the actions of one of its citizens. According to an article in the *Troy Messenger* on July 20, 1921, town officials were continuing to receive letters from across the country in protest of the actions of one of Troy's more eccentric citizens, Joseph Pinckney "Pink" Parker.

Pink, a former Confederate soldier with a bitter hatred for Abraham Lincoln, had a monument created to honor Lincoln's assassin, John Wilkes Booth. Although the town refused to place the monument on the courthouse square,

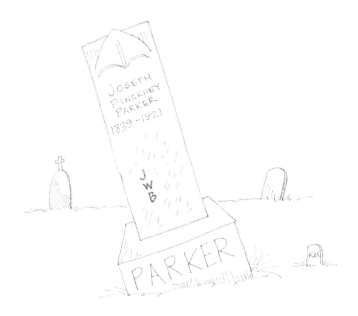

as Parker had hoped, newspapers in the North reported that the town *had* erected the monument, and angry letters poured in. By then, the monument, which had stood in Pink's yard until his death in 1921, had been removed. But the town's reputation remained tarnished.

Pink Parker was born in Coffee County to a wealthy family and served under General Robert E. Lee during the Civil War. When he returned home after the war, he found his home burned, his livestock stolen and the slaves gone. The family's wealth was gone, too, taken by debt. Impoverished, Pink moved to Troy, where he worked as a police officer.

A newspaper retrospective on Pink later reported that he called himself "the bitterest rebel in the South."

Each year on April 15, the anniversary of Lincoln's assassination in 1856, Pink would march through downtown Troy wearing a button with the date and the year of the anniversary and the words "Death of Old Abe Lincoln."

His bitterness cost him friends, and he was forced out of the Baptist church.

In 1906, forty-one years after Lincoln's death, Pink's fury led him to his most outlandish action. He bought a three-foot-tall granite monument and had it inscribed "Erected by Pink Parker in honor of John Wilkes Booth for killing Old Abe Lincoln." He presented it to Troy town leaders to be placed on the square, but they refused the gift. So Pink placed the marker in the yard of his Madison Street home, where it stayed until his death.

This would have been the type of reception Booth expected when he killed Lincoln, rather than being the subject of a massive manhunt and becoming one of history's most vilified men. In a journal Booth kept while on the run after he shot Lincoln, he wrote: "I struck for my country and that alone. A country that groaned beneath this tyranny, and prayed for this end, and yet now behold the cold hand they extend me." Booth was genuinely surprised that he was not hailed as a hero. But he didn't live to see Pink Parker's monument.

It had been in Pink's yard for fourteen years when northern media got wind of it. Some reported erroneously

that townspeople had raised funds to have the marker carved. Stories denouncing Pink Parker, and the town of Troy, ran in the *Washington Post*, the *St. Louis Post-Dispatch*, the *Brooklyn Eagle* and others. One reporter called it the "only monument to the memory of an assassin that stands on American soil."

Despite pleas from various groups, including the Women's League of Republican Voters in Alabama, Pink refused to relinquish his monument.

As Pink's health began to fail, relatives moved him to Georgia to care for him. Pranksters, thought to be a group of small boys, pulled down the marker in Pink's yard that Halloween.

Six months later, Pink died at the age of eighty-two. He was returned to Troy and was buried in Oakwood Cemetery.

His sons took the fallen Lincoln monument to a stonecutter, who removed the inscription and re-inscribed it as Pink's grave marker. According to local legend, the monument was pushed askance by a large thorny bush growing on the grave, and each time it is righted, the bush grows again and pushes the marker aside. The thorn bush is said to grow directly from Pink's heart. Though the monument is tilted, no thorn bushes remain today in the area, which is well maintained.

Pink Parker's monument is located in Oakwood Cemetery on North Knox Street in Troy. When traveling north on Knox Street, enter the cemetery at the second gate. Drive as far as you can and then walk down the slope. Pink's is among the graves near the fence.

Colorful Characters

Birmingham Batman Was Beloved

In Birmingham, Alabama, the Batmobile will finally have a home. An iconic item from Birmingham's past has sat in storage since 1985, gathering dust and fading from people's memories. In 2009, the Birmingham City Council, which had been ready to sell the 1971 specially outfitted Thunderbird known as the Batmobile Rescue Ship, voted to restore it and put it on public display.

Why is a 1971 Thunderbird important to Birmingham's history? The car was once driven by Willie J. Perry, the man known as the Birmingham Batman. Perry became a local icon when he drove the car around the city displaying a sign that read: "Will help anyone in distress." When he came across stranded motorists, he would supply gas or offer use of his jumper cables or a ride home.

Called a "hero," Perry earned the nickname "Batman." He took to the title. He would wear a white jumpsuit and a white helmet featuring a bat logo while on his rounds to find stranded motorists. In addition, Perry drove the elderly to appointments and took children on rides for fun.

His mission, based on the Golden Rule, became so well known that he was featured on the television show *That's Incredible!* in 1982.

Like its owner, the car was out of the ordinary. It was outfitted with a cellular phone, a rarity in the 1980s when they were typically called "car phones" and used by the rich

or dignitaries. The Batmobile also had a color television and a turntable to play records.

It was Perry's beloved car that ultimately killed him. In 1985, at age forty-four, Perry died from carbon monoxide poisoning when he was working on the car and the garage door accidentally was closed.

The city purchased the car for $15,000 and put it in storage at the Southern Museum of Flight. It was then taken to Fair Park. In 2009, with Fair Park being redeveloped, some city council members hoped to display the car at the park. Councilman Roderick Royal told the *Birmingham News*: "If it is a part of our history as we say, then we owe it to the memory of this resident who just wanted to help."

Perry's daughter, Marquetta Renee Hill, responded: "That's what I wanted."

The Big-Hearted Madam

Louise Catherine Wooster spent part of her life as a poor orphan, but before she died she had become known as a Birmingham hero, the lover of debonair movie star John Wilkes Booth and a wealthy woman mourned by the most prominent people.

It turns out, much of her story is her own invention. Lou, as she was known, was born in Tuscaloosa on June 12, 1842. She moved with her siblings and parents, Mary and

William Wooster, to Mobile before she was seven years old. Her father died within two years, and her mother followed in 1857. The two youngest siblings were sent to Mobile's Protestant Orphan Asylum, while Louise went to live with a married sister in New Orleans. Louise's remaining sister, fifteen-year-old Margaret, made a living as a prostitute.

Louise soon left New Orleans, returned to Mobile and took her sisters from the orphanage by forging a letter. Before long, Lou entered a brothel in Montgomery to support herself and then moved to Birmingham sometime before 1873.

It was in 1873 that Birmingham was struck with a deadly cholera epidemic, and Lou Wooster, age thirty-one, endeared herself to people of the city by caring for the sick and preparing bodies for burial.

Lou's "career" flourished, and in the 1880s, she opened a high-class brothel on Fourth Avenue North. By 1887, she was quite wealthy and owned land, buildings and jewelry.

In 1890, Lou told a reporter that she believed Booth was still alive, and the story was recounted in newspapers across the country. According to Lou's book, *The Autobiography of a Magdalen*, published in 1911, she and Booth were lovers before the night in 1865 when he shot and killed Abraham Lincoln, but there is no evidence that this affair took place.

Lou also gave herself a more prominent pedigree in the book and alluded to affairs with many prominent men. She claimed she turned to prostitution only after being used by numerous men. Lou retired from her brothel in 1901

and died on May 16, 1913. She was buried in Oak Hill Cemetery at a service attended by few, although legend says the most prominent men of Birmingham lined up to mourn her.

Lou's legend, perpetuated both by herself in life and by stories handed down after her death, includes the myth that Margaret Mitchell based her *Gone with the Wind* character, Belle Watling, on the Birmingham prostitute. The legend has grown until, in 2000, Alabama Operaworks commissioned the opera *Louise: The Story of a Magdalen*.

One true event about Louise Wooster occurred long after her death. The University of Alabama at Birmingham School of Public Health named an award in the prostitute's honor. Because of her selfless work during the cholera epidemic, UAB officials created the Louise Wooster Public Health Hero award "in recognition of a person or organization that demonstrates a commitment and dedication to the health of the public in ways that go beyond their usual activities."

According to UAB's School of Public Health website: "Without her efforts the City of Birmingham may well have not survived the epidemic."

Huntsville's Molly Teal

North Alabama had its own "big-hearted prostitute." Upon her death, Huntsville madam Molly Teal, who lived from

1852 to 1899, donated her large Victorian home downtown to the city. The building was used as the first infirmary and, later, the first public hospital.

Molly is buried in Huntsville's historic Maple Hill Cemetery.

A Devil in Every Family

One fine day in the 1910s, a Limestone County father took a walk to the barn with his preteen son. Inside a stall was a mule known for being temperamental and capable of bodily harm. The man placed his son inside the stall with the mule, hoping the vicious animal would kick the boy to death.

And he did so on the advice of his preacher.

The man, according to local lore, was told by his religious leader that he must kill his son because the boy "had the devil in him." Unable to kill the boy himself, the farmer left him with the vicious mule, to no avail. The boy survived.

The preacher, the Reverend John S. Barker, led a cult known as the Barkerites in the western part of the county. According to Barker's descendants, the preacher felt there was a devil in every family, and the possessed needed to be killed.

"He knew the Bible from cover to cover and could quote any part of it," said Sally Hess, whose father was one of Barker's nephews. Barker never married. "But he used it for his purpose and not the purpose of God."

In addition to advocating killing those considered possessed, Barker told his congregation that making whiskey was legal as long as it was sold to "non-believers," that a husband and wife of different religious beliefs should separate and that his followers must "donate" to the church whenever he sent his "collection agents" to their homes.

In the book *Legendary Limestone: Colorful Characters and Events* by Bob Henry Walker, Barker was described as "tall, broad-shouldered and raw-boned."

He once worked as a store clerk before going to the Oklahoma Indian territory in 1900. He returned about ten years later, saying he had preached to the Indians, converting them before they could kill him.

After moving in with a family near the Lauderdale County line, Barker began holding church meetings, claiming he could prove anything using scripture. Some of Barker's sermons lasted four hours, and he once preached through an entire night.

His knowledge of the Bible apparently impressed people enough to follow his "teachings." When he told his followers in 1915 to prepare for the end of the world in 1917—on a certain day and month—one old man in the congregation reportedly sold his belongings and gave the proceeds to Barker. Barkerites were not asked to fill a collection plate in church; rather, Barker's armed Mafia-like protectors would go from house to house making collections.

Some followers began to catch on that Barker was not a prophet—perhaps when Armageddon failed to occur—

and he decided to return to Oklahoma, taking a nephew and the nephew's son with him. It was later rumored that the nephew was brought to court in Oklahoma, charged with his son's murder. He supposedly served time on a lesser charge after no body was produced, but some wondered, of course, if the nephew was following the advice of his religious and legal advisor, Barker.

Barker died February 17, 1934, and is buried in western Limestone County in the Barker family cemetery.

"It's an interesting story and I don't mind telling it," said Hess. "When I was little, we sat around the fire and they'd get to talking about the family and things Barker had done. He was a very religious man. But he was an extreme individual. He split up as many marriages as stayed together. He always said there was a devil in every family."

THE LEGACY OF BLIND TOM

A slave boy named Thomas Greene Wiggins, and later Thomas Greene Bethune after the family who owned him, was considered "useless" after his birth in Columbus, Georgia, in 1849. He was blind and was called an "idiot," although experts later suspected he was autistic. But Tom managed to do what no one thought he could: he achieved worldwide fame that has lasted into this century.

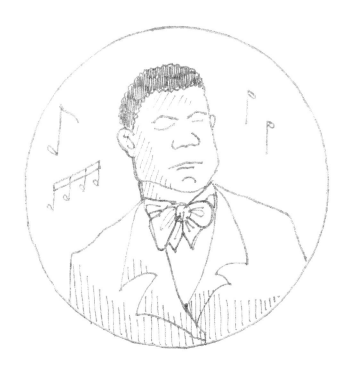

Blind Tom, as the boy was known, was a musical savant who could play any piano piece after hearing it once. He also composed music, which a modern pianist chose to recreate and record in 2000. And in July 2002, ninety-four years after his death, Tom's forgotten grave in a New York cemetery received a headstone in a ceremony attended by surviving family members.

Blind Tom lived with a prominent Athens, Alabama family during the height of his fame and caught the attention

of John Davis, a Julliard graduate and composer intrigued with African American music of the South. Inspired by Blind Tom's special genius, Davis released *John Davis Plays Blind Tom* and created a one-man show based on Tom's life. In addition, Atlanta's 7 Stages Theater produced the play *HUSH: Composing Blind Tom Wiggins*.

A couple in Athens—General William Pinckney Howard and Rebecca Vasser Howard, who grew up in the historic Vasser-Lovvorn home that still stands—were Tom's guardians during an 1871 European tour. A letter addressed to General Howard in England refers to him as Tom's "musical guardian."

At the time, Tom was such a phenomenon that he was asked to perform for Queen Victoria. After returning to the United States, Tom toured Alabama and is said to have performed in Athens. Biographies say it was General James Bethune of Georgia who benefited from Tom's talent. At least three biographies say that Tom earned $100,000 for Bethune during his "career," which would be millions in today's dollars.

Mark Twain was impressed with Tom's talent, calling him an "inspired idiot" who could "play two tunes and sing a third at the same time, and let the audience choose the keys he shall perform in."

At the age of four, Tom was able to reproduce music from memory after hearing it played by Bethune's children. When he was six, he began improvising on the piano and composing music. According to several biographies,

scholars now believe that Tom was an autistic savant, much like Dustin Hoffman's character in the film *Rain Man*.

Following the Civil War, Tom's father, Domingo Wiggins, a field slave, and his mother, Charity Greene, were pressured to give custody of Tom to the Bethune family. Two court battles and many years later, an adult Tom was returned to his mother, but by then she was unable to care for him.

When Bethune died, Tom lived in New York with Bethune's estranged daughter-in-law. He is buried in Evergreens Cemetery in New York City's Brooklyn borough, where he lay for nearly a century with no headstone, until Davis and Tom's descendants had a monument erected. Now Blind Tom, the "useless idiot," lives forever through his music.

Last Man Killed in the Civil War

History books state that the last battle of the Civil War was fought at Palmito Ranch, Texas, on May 12 and 13, 1865. On May 13, a month after Lee surrendered at Appomattox, Private John J. Williams of the Thirty-fourth Indiana was recorded as the last casualty of the Civil War. That battle was a Confederate victory.

A week later, an event would occur that some claim is the true last battle of the war. A detachment of Union soldiers from the First Florida U.S. Cavalry was sent from Montgomery on May 11 to Eufaula. The twenty-five men

were escorting a mail shipment. After the surrender, many Confederate soldiers were wandering through the region, trying to get home. The men of the First Florida U.S. Cavalry stopped to rest their horses and take a few days' leave, with plans to regroup on May 19 at Hobdy's Bridge.

The cavalry unit's leader, Lieutenant Joseph Carroll, soon would learn that several groups of Confederate guerillas were roaming the area. He decided to gather the men whose whereabouts he knew and return to Montgomery. The group left a few days before May 19.

The majority of the detachment arrived for the rendezvous as scheduled and were fired on by Rebel guerillas. Corporal John W. Skinner of the cavalry's Company C was killed—six days after Private Williams. Three of the Union soldiers wounded in the skirmish later fought to get their pensions. Initially, the government denied the claims, saying the war had ended with Lee's surrender. But a higher official would rule that when the men returned as ordered to Hobdy's Bridge, they were returning to active duty. The pensions were granted.

The three men who were the last casualties of the war were William Smith and Nathan Mims of Company F of the First Florida U.S. Cavalry and Daniel V. Melvin from Company C. According to Smith's military records, he was shot in the right arm, right shoulder, left hand and left side. He stayed in St. Mary's Hospital in Montgomery until June 1, 1865.

The wood-plank Hobdy's Bridge long ago succumbed to the elements. It was located where Alabama 130 crosses the Pea River, seven miles west of Louisville, Alabama.

Manson's Girl Arrested in Alabama

Many people are familiar with the name Patricia Krenwinkel, one of the Manson family members who went on a murder spree in California in 1969. But what they may not know is Krenwinkel's connection to Alabama.

Patricia Dianne Krenwinkel was born December 3, 1947, in Los Angeles, California. Her father sold insurance, and her mother was a homemaker. Krenwinkel's parents divorced when she was seventeen, and her mother moved to be near family in Mobile, Alabama, while Krenwinkel stayed behind with her father in California. She moved to Alabama briefly to attend the Spring Hill College in Mobile, a Jesuit school. She considered becoming a nun but soon dropped out of school and returned to California.

In 1967, the self-conscious young woman visited Manhattan Beach and met Charles Manson, the first person she said who made her feel beautiful. She soon moved to Spahn Ranch, where the remainder of Manson's followers lived.

While part of "The Family," Krenwinkel was known as "Katie." On August 9, 1969, when she was twenty-one years old, Krenwinkel accompanied Susan Atkins and Charles "Tex" Watson on a mission to murder the occupants of the home at 10050 Cielo Drive in Los Angeles, which at that time was owned by actress Sharon Tate and her director husband, Roman Polanski. Tate was eight months pregnant,

Colorful Characters

and with her husband away directing a film, she had several friends staying at the home to keep her company.

Krenwinkel dragged coffee heiress Abigail Folger from a guest bedroom into the living room and began stabbing her. When Folger escaped and ran screaming onto the lawn, Krenwinkel gave chase, caught her and continued stabbing until Folger's white nightgown turned red.

The remainder of the home's occupants—including Tate, despite her pleas for the life of her unborn child—were brutally murdered by the other members of the group. The next night, Krenwinkel again followed Manson's orders when she accompanied Manson, Watson, Atkins, Steve Grogan, Leslie Van Houten and Linda Kasabian to the home of Leno and Rosemary LaBianca. Only Watson, Krenwinkel and Van Houten participated in the stabbing deaths of the couple while the other family members waited outside.

The next week, police arrested Manson Family members after spotting stolen car parts at the ranch. After the group was released on a technicality, members of the family began leaving. Manson moved the family members to Barker Ranch, but police soon caught up with them, and the group was arrested in October 1969, again for auto theft. They were not suspects in the brutal murders until Susan Atkins talked to a cellmate, who reported the confession to authorities.

Manson told Krenwinkel she should return to Mobile to live with her mother. After authorities learned of her involvement in the murders, Krenwinkel was arrested in Mobile in December 1969.

Indictments followed on seven counts of first-degree murder and one count of conspiracy to commit murder. However, an attorney for Krenwinkel claimed her arrest came before warrants were received charging her with the crimes.

According to a December 5, 1969 article in the *St. Petersburg Times* in Florida, Mobile Police Captain Don Riddle admitted that the warrant for Krenwinkel's arrest arrived two days after her arrest. Mobile Circuit Court Judge Joseph M. Hocklander ruled that the arrest was not illegal, but Krenwinkel continued to fight extradition. At the time, she said she fled to her mother's home because she was afraid Manson would kill her. In February 1970, she waived extradition and voluntarily returned to California to stand trial.

According to the book *Helter Skelter* by Manson prosecutor Vincent Bugliosi, Krenwinkel's mother Dorothy testified at the penalty phase of the trial, saying, "I did love my daughter; I will always love my daughter and no one will ever convince me she did anything horrible or terrible."

Bugliosi also wrote that letters from Krenwinkel's father and from her favorite priest at Spring Hill College were introduced on her behalf during the penalty phase.

Like the other family members to stand trial—Atkins, Watson, Kasabian and Manson—Krenwinkel was found guilty in 1971 and sentenced to death. When California outlawed the death penalty in 1972, her sentence was commuted to life in prison. She is reported to be a model prisoner who works on numerous outreach projects. She is currently the longest-incarcerated female inmate in California.

Alabama Victim

One of the victims of the Manson Family was Jay Sebring, who was staying with Sharon Tate—his former fiancée—the night of August 9. Sebring was born Thomas John Kummer in Birmingham, Alabama, but his family would soon move to Michigan. Kummer changed his name to Sebring and became a celebrity hairstylist. His clients included the Doors' Jim Morrison (who also would die young), Steve McQueen, Warren Beatty and Kirk Douglas. He was only thirty-five years old when he was brutally murdered.

AMERICA'S FIRST HERO OF WORLD WAR I

The Sunday, April 26, 1918 edition of the *Times Daily* in Florence, Alabama, declared that Memorial Day be celebrated in honor of local resident Homer Givens. That Thursday, declared National Memorial Day, residents gathered in the Coffee High School gym to join in prayer and song and to hear speakers. Also, Red Cross officials would be delivering "the Cross of War bestowed upon 20-year-old Homer Givens for extraordinary bravery on the battle front in France." France's Croix de Guerre was the first such honor bestowed on an American,

giving young Homer the label "America's First World War I Hero."

The article stated that the cross was sent home from France and delivered by Red Cross Major George W. Simmons, who was to present it to Givens' father.

A historical marker in Lauderdale County at Seven Points, which was where the Givens home was once located, recounts Homer's heroic actions:

> *Following a bloody two-hour battle on November 1, 1917, Corporal Givens stood alone after his comrades had fallen. He then managed to kill three enemy soldiers before being severely wounded by twenty-three pieces of shrapnel. Givens was decorated with France's highest military honor. His award ceremony was attended by General John J. Pershing, Commander of the American Expeditionary Forces.*

America had entered the war just months before Homer's famous battle. Although Allied Forces had been fighting since 1914, President Woodrow Wilson had been reluctant to join the fighting until Germany began unrestricted submarine warfare on January 9, 1917, and caused loss of many lives at sea, including those on board the sunken *Lusitania*. Wilson asked Congress to declare war on April 6.

On April 17, 1918, two weeks before the Memorial Day event in Florence, the *New York Times* ran an article on Homer and the arrival of his Cross. The article stated

that Homer remained in the hospital overseas, "where he is slowly winning back to health as the first American hero." While recuperating, he told officials he wanted "above all else to have his mother receive his decoration," the article stated.

When Major Simmons told Homer he would deliver the cross to Florence, Alabama, the young soldier began to cry. When Simmons made his visit to Homer in the hospital, all but eleven pieces of shrapnel had been removed.

Homer Givens returned to Florence to live following the war. He died in 1971 and is buried in Greenview Cemetery.

THE HANGING OF OUTLAW TOM CLARK

The three men were going to die. They knew that. Most people agreed that they needed to die. But when they were taken to the jailhouse in Florence, Alabama, one September night in 1872, they seemed more concerned that the hot, dusty cells would ruin their elegant clothes.

One of the men was an outlaw known as Mountain Tom Clark, who had bragged about killing as many as eighteen people and had committed an untold number of other crimes.

People knew the name Tom Clark. They feared it.

Clark was part of a gang of post–Civil War bandits who terrorized residents across the South. The gangs

consisted of deserters and soldiers from both the Union and Confederate armies. Clark was known to belong to a gang called Clifton Shebang, or the Buggers.

With Clark when he was arrested were two men suspected of entering homes around Florence during the previous night, including the residences of Judge Allington, James Hancock and R.T. Simpson. Gold watches and other items were taken. In addition, a man from Athens, forty miles east of Florence, had come into town the night before to report that as many as nine homes in Athens had been burglarized of similar items.

Florence Marshal William E. Blair, along with William Barks, William Joiner and W.E. Warson, captured the men, who had dressed and stopped for dinner a few miles from Gravelly Springs near Waterloo. The *Lauderdale Times* reported on September 10, 1872: "A search of their persons discovered nothing, but on examining the buggy, the pin of a breastpin was observed sticking through the lining of the buggy top." The captors immediately went to search the men's lodging and discovered eight watches and a number of men's breastpins, as well as a case filled with burglar's tools.

The men were escorted to jail, and the party of captors was joined by the marshal from Athens, as well as curious citizens. The newspaper stated: "Florence turned-out en masse, as the party rode in town much excitement prevailed."

At the jail, Sheriff Hudson had installed eight men to guard the bandits because he feared the jail was not

Colorful Characters

secure enough to hold the bandits. But the sheriff needed not have worried about the bandits getting out. It was a mob of angry citizens who got in, the newspaper account continued: "About midnight a great crowd came to the jail and demanded the keys. The guard refused to give them up, and fired on the mob…the three men taken out and carried immediately to an adjoining square, and hanged by the neck until they were dead. The three were suspended from a tree, which stands in the rear of the site of the old Masonic Lodge."

The newspaper printed an "Extra" edition about the incident. Headlines read: "Three Men Hung on One Tree! Thos. Clark, the Notorious Outlaw, Executed!"

Who were the men with Clark?

No one knew beyond this description:

> *One was a short, stalwart man, with the initials F.R. and a star, in Indian Ink, on his right arm, and two hearts pierced by an arrow on his left hand; and one is supposed to be Gibson. We understand that one of the robbers directed his portion of the $365, in money, which was found on their persons, to be sent to his sister, Miss Kate Schilee, of Indianapolis, Indiana. The same man attempted to escape, was shot by some person, unknown, recaptured, and hung with the others. It is the opinion of Dr. Hannum, who examined his wound, that death would have resulted from the pistol shot. The younger robber marched up boldly to the tree*

and requested the executioners to hold him up and drop him, instead of drawing him up.

And while the *Lauderdale Times* reporter made the statement that he hoped the world would not judge Lauderdale Countians as a lawless group, he added:

Tom Clark, who boasted that he had murdered, in cold blood, sixteen men, deserved hanging sixteen times over. The others, no doubt, would have slain their scores if they had found it necessary to cover their villiany [sic]… *This was no Ku-Klux affair, but simply the legitimate effect of an indignant and outraged public feeling…We are opposed to mob law, but these men met a death richly deserved, and over their fate we shed no tears.*

From here news accounts end and legend takes over. According to a historical marker located adjacent to Florence Cemetery on East Tennessee Street in Florence, someone remembered Clark boasting, "Nobody will ever run over Tom Clark," and townspeople decided they would bury him beneath a road.

The marker states: "This notorious outlaw gang leader who boasted that no one could ever run over Tom Clark lies buried near the center of Tennessee Street where now all who pass by do run over him."

Lane Cake Is a True Southern Welcome

It was in 1960 that one of Alabama's most famous residents, Nelle Harper Lee, immortalized a lesser-known woman from the state's past: Emma Rylander Lane. In Harper Lee's only novel, the Pulitzer Prize–winning *To Kill a Mockingbird*, her character Scout uttered these words in Chapter 13: "Miss Maudie Atkinson baked a Lane Cake so loaded with shinny it made me tight."

The young Scout was referring to the alcohol baked into the cake, which is a real confection that originated in Alabama. It is a white sponge cake made with egg whites and consisting of layers filled with a mixture of the egg yolks, butter, sugar, raisins and whiskey.

In *Mockingbird*, the character Maudie Atkinson baked a Lane Cake to welcome Aunt Alexandra, who had come to live with the Finches. Being served a Lane Cake is a high honor because the confections are difficult to bake.

Earlier in the story, in Chapter 8, Miss Maudie wanted to thank a neighbor who came to her aid when her home burned, saying: "Mr. Avery will be in bed for a week—he's right stove up. He's too old to do things like that and I told him so. Soon as I can get my hands clean and when Stephanie Crawford's not looking, I'll make him a Lane Cake. That Stephanie's been after my recipe for thirty

years, and if she thinks I'll give it to her just because I'm staying with her she's got another think coming."

Scout continued: "I reflected that if Miss Maudie broke down and gave it to her, Miss Stephanie couldn't follow it anyway. Miss Maudie had once let me see it: among other things, the recipe called for one large cup of sugar."

The Lane Cake was created by Emma Rylander Lane of Clayton, who published the recipe in her 1898 cookbook, *Some Good Things to Eat*, after the cake won first prize at a fair. Lane initially called the confection Prize Cake until a friend encouraged her to lend her own name to it.

Lane died in April 1904 while in Guadalajara, Mexico.

The Recipe

In her day, Lane made the cake in medium pie tins lined with brown paper rather than in cake pans. The initial recipe called for "one wine-glass of good whiskey or brandy" in the filling. She also said the cake tasted best if made a day or two before serving.

These days, dozens of variations can be found, although Lane's 1898 recipe is more difficult to come by. Coconut, dried fruit and nuts are commonly added to the filling, and some bakers like to use the filling mixture to ice the cake.

Here is an updated version of the recipe:

Cake:
2 cups sugar
½ pound plus 4 tablespoons butter

Colorful Characters

1½ teaspoons pure vanilla extract
3½ cups flour
4 teaspoons baking powder
1 teaspoon salt (optional)
1¼ cups milk
8 egg whites, beaten until stiff but not dry

Preheat oven to 375 degrees. Butter the bottoms and sides of three nine-inch layer cake pans. Coat the bottoms and sides of the pans with flour and shake out the excess. Set pans aside. To make the batter, beat sugar and butter together until light and fluffy. Beat in vanilla extract. Sift together flour, baking powder and salt. Sift a second time. Add flour mixture alternately with milk to batter. Add ¼ of egg whites and beat them in. Fold in remaining egg whites. Spoon equal portions of batter into each of the prepared pans. Bake for 20–25 minutes. Place on a rack and let stand 10 minutes. Turn cake layers out onto a rack to cool. Meanwhile, prepare filling. Yield: ten or more servings.

Filling:
9 egg yolks
1¼ cups sugar
1 teaspoon grated orange rind
⅓ cup bourbon
¾ teaspoon pure vanilla extract
½ teaspoon ground mace
1 cup chopped pecans
1 cup shredded coconut, preferably fresh

1 cup candied cherries, cut into quarters
1 cup raisins

Combine egg yolks, sugar and orange rind in the top of a double boiler and place the top pan in a basin of simmering water. Cook gently, stirring constantly, until the mixture thickens enough to coat a wooden spoon. Do not let the mixture boil or the yolks will curdle. Remove from heat and beat in bourbon, vanilla, mace, pecans, coconut, cherries and raisins. Let cool to room temperature. Spread between cake layers. Top cake with icing.

Icing:
2 egg whites
1 cup sugar
½ cup water
¼ teaspoon cream of tartar
⅛ teaspoon salt (optional)
1 teaspoon pure vanilla extract

Beat egg whites until stiff and set aside. In a saucepan, combine sugar, water, cream of tartar and salt and bring to a boil, stirring. Cook for 5 minutes over medium heat. Add vanilla. Pour sugar mixture over egg whites, beating constantly. Frost top and sides of the cake.

The Exploit of the Murphree Sisters

On Friday, May 1, 1863, sisters Celia and Winnie Mae Murphree were alone at their home in Blount County. Being home alone would have been a rare occurrence for the young women—Celia was about twenty-one and Winnie Mae was nineteen—as they were two of sixteen children born to Elijah Murphree and Sarah Easley Murphree. Their father had died in November 1861; one brother, Thomas, had died as an infant. Some accounts of the Murphree sisters' story state that the sisters were not alone but were babysitting younger siblings that May afternoon during the Streight-Forrest Campaign.

The Murphrees were no strangers to the dangers of the Civil War. Three of the Murphree boys to fight in the war would be killed in battle: Isaac S. Murphree in 1864 at the age of twenty-seven, Benjamin S. Murphree in 1862 at the age of twenty-five and Levi Murphree in 1863 at age twenty.

On that May day, as Confederate General Nathan Bedford Forrest was raiding Union Colonel Abel Streight's forces as they attempted to cross nearby Locust Fork, the Murphree sisters were confronted with a battle of their own when three straggling Union soldiers appeared at their home with rifles. The men reportedly were looking for food and drink. One story states that they requested alcoholic refreshment, and it's possible the alcohol combined with the soldiers' fatigue allowed them to be captured.

A historical marker near the site of the home states: "When the soldiers fell asleep, these two young girls took rifles, marched soldiers to headquarters of General Forrest, bivouacked at Royal Crossing on Warrior River." Yet another account claims that the sisters added a sedative to the soldiers' drinks and the men awoke looking into the barrels of their own rifles. The sisters were proclaimed heroes of the Confederacy.

According to genealogical records, they went on to have families of their own. By the next year, Celia had married John C. Reneau. They had seven children. Celia died in 1899 and is buried in Antioch Methodist Cemetery in Oneonta.

Winnie Mae married Asa Bynum Jr. in 1866. They had eight children. Winnie Mae died November 29, 1899, in Texas and is buried at Oak Branch Cemetery in Ellis County, Texas.

Brothers' Store Became Oldest in State

In the late 1800s, brothers James B. Harrison and Daniel T. Harrison opened a store on Jefferson Street in downtown Huntsville to sell tobacco. In 1897, Daniel and a third brother, Robert, bought a small building on South Side Square for the tobacco business. They couldn't have

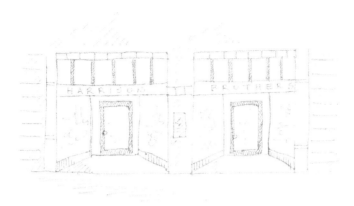

realized they had just established what would become the longest-operating hardware store in the state.

A fire at the turn of the century damaged the majority of the businesses on the south side of the courthouse square, including the tobacco shop and the adjoining space, where another merchant sold furniture and other items.

The Harrison brothers bought the fire-damaged adjoining building, knocked down a wall and expanded. Soon they were selling furniture, appliances, crockery and, eventually, hardware. It came to be called Harrison Brothers Hardware.

In 1902, a freight elevator operated by a specially made pulley system was installed to help lift furniture from the basement to the main merchandise floor. The elevator still

works today. A skylight that was built above the elevator to let light into the store also remains intact.

The business was inherited by Robert's sons, Daniel F. and John, who operated the store for several more decades. The Harrison brothers were notorious for shunning advertising, and the younger Harrisons apparently eschewed change. Rather than purchase modern merchandising displays, they kept the ones their relatives had bought many decades before. The store operated almost as a time capsule.

The buildings were listed on the National Register of Historic Places in 1980. When John Harrison died in 1983, the store became endangered. John had been the last of the descendants who wanted to operate the business. There seemed no reason to keep an old hardware store intact.

A group of Huntsvillians disagreed and took unusual measures to preserve this portion of Huntsville's history. In 1984, the nonprofit group Historic Huntsville Foundation purchased the store. The intent of the group was to preserve the business while making it self-supporting. The result is a "store museum." Because the Harrison brothers were hoarders and threw few items away, the nonprofit group has discovered many treasures within the store's walls. Receipts from the brothers' 1850s tobacco shop have been found, and as recently as the early 2000s, a collection of the brothers' license plates was discovered. The oldest dates to 1919, and the collection likely is made up of plates used on

the families' cars not long after autos became common sights downtown.

On display in the store is the brothers' ledger, a large accounting book set among other items that would have been found on the original desk. The upper shelves of the store contain the decades-old hardware and fixtures the brothers stocked, while shelves below include items of local interest, gardening tools, gifts, reproduction vintage toys, jewelry and many other trinkets. The store is operated six days a week by a team of volunteers.

Visitors who purchase items in the store can watch as the sale is rung up on the antique cash register and get a glimpse of Harrison, an automatronic plush tabby cat purchased by a volunteer in 1985. Harrison has watched over the store since that time, his head slowly rotating, despite the many transplants of his "heart," a small motor.

Today, Harrison Brothers Hardware is a popular tourist attraction in Huntsville. In 2001, it was designated as a Save America's Treasures project by the U.S. Department of the Interior.

Harrison Brothers Hardware is located at 124 South Side Square in downtown Huntsville. It is open weekdays, 9:00 a.m. to 5:00 p.m. and Saturdays 10:00 a.m. to 4:00 p.m. For more information, call (256) 536-3631 or (800) 533-3631.

The Conscientious Cooperator

Desmond T. Doss Sr. of Piedmont held the honor of being one of three conscientious objectors to receive the Congressional Medal of Honor for non-combat achievements and the first to receive the medal. Though he was a longtime resident of Alabama, Doss was born in 1919 in Lynchburg, Virginia, and lived for thirty years in Rising Fawn, Georgia.

Because he was a Seventh-Day Adventist, Doss believed in following the sixth Commandment: "Thou shalt not kill." He refused to carry a weapon or be on duty on the Sabbath. Still, he wanted to serve his country during World War II so the five-foot, six-inch, twenty-three-year-old Doss enlisted in the army in 1942 as a conscientious objector and served as a medic in the Seventy-seventh Infantry Division.

On May 5, 1945, while under attack from the Japanese, Doss helped seventy-five wounded soldiers escape capture on the island of Okinawa.

President Harry Truman bestowed the Medal of Honor on Doss on October 12, 1945. A critically acclaimed documentary on Doss called *The Conscientious Objector* was released in 2004.

Doss died March 23, 2006, at the age of eighty-seven. Upon his death, church officials released this statement: "Doss never liked being called a conscientious objector. He preferred the term conscientious cooperator."

He is buried in Tennessee's National Cemetery in Chattanooga. In 2008, a two-mile stretch of Alabama Highway 9 in Piedmont was named Desmond T. Doss Sr. Memorial Highway.

THE FAMED INVENTOR WHO NEVER MADE A CENT

Mary Anderson was born at Burton Hill Plantation in Green County, Alabama, on February 19, 1866, and lived a comfortable but unassuming life. Yet upon her death at age eighty-seven on June 27, 1953, her obituary was printed in *Time* magazine and the *New York Times*. Anderson's claim to fame was an invention from which she never made any money—windshield wipers.

Anderson, who never married, was born to John C. and Rebecca Anderson. After her father died in 1870, she, her mother and her sister Fannie lived comfortably from her father's estate. In 1889, they moved to Birmingham, where they built, ran and lived in the Fairmont Apartments on Twenty-first Street at Highland Avenue.

Anderson lived for a while in California, where she ran a cattle ranch and vineyard, but she returned to Birmingham in 1890 to help care for an elderly aunt who lived in the apartments. Upon the aunt's death, the family found a

chest of gold and jewelry that allowed them to continue to live without worrying about finances.

Anderson apparently used some funds to travel, and she was visiting New York in 1903 when she recognized the need for a device to clean windshields. Although cars were not common at the time—Henry Ford had not manufactured his Model A and the Model T would not be designed until 1908—Anderson thought the device could be used for streetcars. She was riding on a streetcar in a snowstorm and noticed the driver had to lower the windshield in order to see the road.

Anderson knew there must be a better way, and she went home and drew a design for a blade operated by a lever inside the streetcar. She was issued patent No. 743,801 for the invention.

While similar devices had been attempted, Anderson's actually worked and had the added benefit of being removable when weather was nice. Anderson apparently only made one attempt to market her invention in 1905 but was turned down. Some people thought the motion of such wipers would distract drivers; many thought the invention silly.

Within a decade, thousands of people owned cars, and mechanical windshield wipers—not the spring-loaded design developed by Anderson—were standard equipment.

In 1917, another woman—Charlotte Bridgewood—would patent the first electric wipers, called Storm Windshield Cleaners.

Anderson continued living in the Fairmont Apartments and managed the building until her death. She was on a visit to her summer home in Monteagle, Tennessee, when she died. She is buried in Elmwood Cemetery in Birmingham.

HE MADE A DISHONEST WOMAN OF HER

Katherine Lackner, born in 1866, grew up to become a respectable wife and then a mother. She lived the life expected of a lady in the mid-1800s. And she was content—until she met a portly, rakish riverboat captain who swept her off her feet and made a dishonest woman of her.

After meeting William Simpson "Simp" McGhee, Kate abandoned her husband and child, became the lover of one of Decatur's most notorious residents and set up a brothel on Bank Street just yards from the Tennessee River.

The brothel was known as Miss Kate's Place, a bawdy house where for a fee men could enjoy the company of women—unless it was Thursday. Thursday nights were when Simp McGhee steamed into town in one of his favorite boats, the *Chattanooga* or the *James Trigg*, and when he blew the boat's whistle, Miss Kate would shoo everyone out the door and wait to spend an intimate night with her lover. On Friday mornings at 9:00 a.m., Simp would leave again for another adventure delivering loads along the Tennessee.

Captain McGhee worked for the Tennessee River Navigation Company and reportedly owned a saloon and Miss Kate's brothel at times. At the saloon, located next door to Miss Kate's, McGhee would sit at the bar next to his pet pig. According to legend, the pig often joined Simp in drinking a mug of beer.

Not much is known about Simp's early life. People said he was an orphan born December 15, 1859. He is reported to have said: "My mama was the Tennessee River." He began working for the riverboat company when he was about thirteen and remained a captain until months before his death on June 16, 1917.

In *The Story of Decatur, Alabama*, by William Jenkins and John Knox, a local history book produced in 1970, a local resident said of Simp: "He was a debauchee but with a heart as big as all outdoors."

He worked the route to Chattanooga and back, and it was a dangerous area of rapids known as "the chute" that eventually was his undoing. Although riverboat captains were required to used a winch and rope apparatus to help pull their boats through the risky pass, a three-hour-long proposition, McGhee was known to push his boats to full throttle and steam through the area, at grave risk to his crew and boat.

When federal agents caught McGhee, they took his captain's license. He reportedly moved into Kate's Place, but not knowing how to live life off his beloved river, McGhee died within three months. He is buried in a cemetery near Guntersville.

Kate would live another three decades. She died April 12, 1947, and is buried in Decatur City Cemetery. The rambling house from which Miss Kate conducted her business was torn down in the 1960s, and apartments now stand on the site.

In 1986, a Decatur couple opened a restaurant on Bank Street named Simp McGhee's in honor of the man who provided so many stories to local history.

THE GIGGLING GRANNY KILLED 'EM ALL

In the early 1950s, Nannie Doss looked like a typical grandmother. She wore cat-eye glasses and a bouffant hairdo and enjoyed caring for her family.

The problem was, Nannie's care proved deadly. By 1955, she would be on trial for murder after authorities began to grow curious about the series of deaths that seemed to follow her.

She was dubbed by the press as the Giggling Granny because of her inappropriate, girlish giggling despite the serious nature of the charges she faced. Law officials eventually determined that she killed four husbands in four states—Alabama, North Carolina, Kansas and Oklahoma—but her victims likely numbered fourteen, including her mother, two daughters, a grandson, a nephew and one of her mothers-in-law.

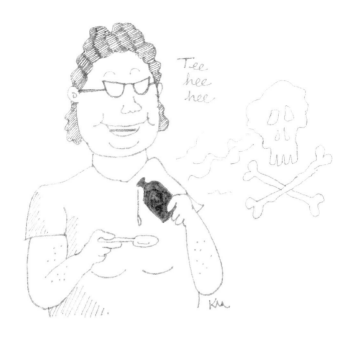

She would finally face trial in the death of her husband Samuel Doss in Tulsa, Oklahoma, in 1954.

Nannie was born Nancy Hazle on November 4, 1905, to James and Lou Hazle in Blue Mountain near Anniston, Alabama. Nannie had one brother and three sisters. They were raised by a father known to be extremely strict and controlling. Their education was erratic because the children often were taken from school to work on the family farm. Nannie spent much of her time reading her mother's romance magazines, particularly the lonely hearts column.

Colorful Characters

Because she would later meet men through this method, some dubbed her the Lonely Hearts Husband Killer.

Nannie's first husband was the lucky one. She married Charlie Braggs in 1921 when she was sixteen, just four months after meeting him. They would have four daughters. When they divorced in 1928, he was still very much alive.

Nannie resumed reading lonely hearts columns and writing to men. She would soon meet Frank Harrelson of Jacksonville. They married in 1929. He reportedly was an abusive alcoholic. Frank died suddenly in 1945. By 1943, Nannie had two grandchildren. By 1945, they, too, died mysteriously while in her care.

Nannie's third husband was Arlie Lanning of Lexington, North Carolina, an Alabama native. She met him in 1947 through, of course, a lonely hearts column and married him three days later. She wouldn't stay with him long. In 1950, Arlie died after collapsing just after drinking a cup of coffee and eating a bowl of prunes. His cause of death was listed as heart failure. His last words were reportedly: "It must have been the coffee." During Nannie's marriage to Arlie, Arlie's mother died in her sleep, another death later attributed to Nannie.

On one of Nannie's trips while married to Arlie, she went to stay with her sister Dovie, who was bedridden. Soon after Nannie came to stay, Dovie, too, died.

In 1952, Nannie met and married retired businessman Richard L. Morton of Emporia, Kansas. Within months, Richard was dead.

In June 1953, Nannie married Samuel Doss of Tulsa. In September, Samuel was admitted to the hospital and would soon die.

This time, authorities were suspicious. After an investigation, Nannie was arrested. Nannie confessed to killing four of her husbands, her mother, her sister Dovie, her grandson Robert and Arlie Lanning's mother, but she was taken to trial only in the death of Samuel Doss. Nannie pleaded guilty on May 17, 1955, and was sentenced to life in prison. She died of leukemia in the hospital ward of the Oklahoma State Penitentiary in 1965.

Following are some other Alabama black widows.

Marie Hilley

Audrey Marie Hilley was born in 1937 in Anniston. She would be convicted of killing one husband, Frank Hilley, and attempting to kill her daughter, Carol, with poison. Marie married Frank in 1950, and he died in 1975.

Hilley's mother, Lucille Frazier, also died in Hilley's care, as did her mother-in-law, Carrie Hilley. The final count of Marie Hilley's victims—like her motive itself— remains unknown.

When doctors became suspicious of what was making Carol sick, they discovered arsenic in her system. Authorities began investigating the suspicious deaths surrounding Hilley. She was indicted in 1979 for the attempted murder of Carol but escaped while free on $14,000 bond. She

not only created one new identity, Robbi Hannon, but also portrayed Robbi's invented twin sister, Teri Martin. As Robbi, Marie married John Homan in Marlow, New Hampshire, in 1981. When "Robbi" suddenly disappeared, "Teri" appeared to console her "brother-in-law." Co-workers suspicious of Robbi-Teri alerted police, and Marie Hilley went back to jail in January 1983. She was sentenced to life in prison for the death of Frank Hilley, plus twenty years for the attempted murder of her daughter, Carol.

In 1987, authorities made the mistake of granting Marie a furlough from a women's prison in Wetumpka, and she never returned. She was eventually found in Anniston. After spending days roaming outdoors in winter, she was suffering from severe hypothermia. She died that afternoon.

Betty Jo Green

On October 1, 1986, newspapers across the state carried the headline: "Jury convicts woman in arsenic poisonings."

The news stunned the twenty thousand residents of the city of Athens in northern Alabama. Betty Jo Green, born June 14, 1931, was charged with the arsenic poisoning deaths of her ex-husband and sister-in-law. She also was charged with the attempted murder of her fiancé, Arthur Self. It was Self's stay in Huntsville Hospital in 1984 that raised the suspicions of Limestone County sheriff's deputies. After exhibiting strange symptoms, he was diagnosed with arsenic poisoning.

The bodies of Green's ex-husband, Glenn Orman Green, who died in 1978, and his sister, Grace Blankenship, were exhumed in 1984. Forensics experts determined that they, too, had been poisoned.

A psychiatrist for the defense stated that Betty Jo claimed she had another woman living in the left side of her body, but experts for the prosecution found Betty Jo competent to stand trial. She was convicted and is serving a life term in Julia Tutwiler Prison for Women.

Part II
Strange Sites

The Tree that Owns Itself

For two hundred years, the old post oak tree grew in the picturesque town of Eufala. It stood in front of the home of Confederate Captain John A. Walker and survived a fire that destroyed the house. In 1919, an intense tornado struck Eufala, but the mighty oak stood strong.

In 1936, Garden Club President Mrs. Leonard Y. Dean had the idea to preserve the sixty-six-foot-tall, eighty-five-foot-wide tree as a local landmark. At the request of the Eufala City Council and Mayor Hamp Graves Sr., Lieutenant Governor Charles S. McDowell drew up a "deed of sentiment," which granted the tree its freedom. The tree now owned itself.

Dr. J.L. Houston donated an iron fence to protect the tree and a bronze plaque to tell visitors its story. The tree was dedicated during a ceremony on April 8, 1936. Also at that time, it was christened the Walker Oak.

A quarter century later, on April 9, 1961, the massive tree was felled by a tornado. Area newspapers published obituaries for "The Tree that Owned Itself." A replacement tree was donated by International Paper Company, but it soon died. The tree that currently stands on the site is the third tree.

The inscription on the plaque reads:

The tree that owns itself
Planted and dedicated
April 19, 1961
Replacing the Walker Oak
Felled by wind April 9, 1961
Original deed granted by
City of Eufala to the
Oak Tree
April 8, 1936
Only God can make a tree
Replacement by International Paper Co.

The fence was built by Milton L. Lucas Sr., who worked for Eufala Iron Works. Descendants of the Lucas family keep the fence repaired in his memory.

The Georgia Tree

Athens, Georgia, is home to another Tree that Owns Itself. This tree was first reported in a local newspaper in 1890, after Professor W.H. Jackson made an odd request in his will. Jackson, who had always enjoyed the tree's shade, hoped to guarantee its survival. He wrote: "For and in consideration of the great love I bear this tree and the great desire I have for its protection for all time, I convey entire possession of itself and all land within eight feet of the tree on all sides."

In 1942, the four-hundred-year-old oak was felled by strong winds. In 1946, members of a local garden club planted an acorn from the original tree, which also was granted its freedom. It is known as "The Son of the Tree that Owned Itself."

DISMALS CANYON: OUTLAW HIDEOUT

By day, it is easy to imagine outlaws hiding in the dark, shaded areas between boulders or along crevices in Dismals Canyon, Alabama.

It is easy to picture the day-to-day activities of the Chickasaw Indians who were imprisoned within the canyon's natural boundaries before being forced to walk to Muscle Shoals and begin the Trail of Tears.

By night, when moonlight is shut out by the dense canopy of trees, it is just as easy to imagine the spirits of those people lurking in the shadows of the building-sized boulders tossed around the canyon floor by an ancient earthquake.

Legend says that Aaron Burr hid for about four months in this wondrous, lush land of ferns, streams and caves, leaving behind a musket and a cot. Local lore says that Burr, who fatally shot Alexander Hamilton in an 1804 duel in New York while Burr was vice president of the United States, came to the canyon following the duel, but most historical accounts state that he went to his daughter's South Carolina home at that time. It was later, after Burr was charged with treason in 1807 for his alleged plot to take over western states and form a new nation—a charge Burr denied—that Burr was known to be in Alabama. Burr was arrested in Washington County but was never convicted of the crime.

Jesse James also was rumored to have holed up in the canyon. Jesse was known to be in the area when he and his brother Frank were accused of robbery of a United States Army Corps of Engineers payroll in Muscle Shoals in 1881. After a sensational trial in Huntsville in 1884, two years after Jesse had been shot to death, Frank was acquitted of that crime.

The canyon's proximity to the Natchez Trace, which was known as the Devil's Backbone, made it a choice hideout for many outlaws who robbed and murdered travelers along the

Trace. Before that period, the canyon was home to Pueblo, Chickasaw and Cherokee Indians. According to the Dismals Canyon website at www.dismalscanyon.com, U.S. troops rounded up the Chickasaw Indians in 1838 and held them under guard in the canyon for two weeks before they were taken to Muscle Shoals to embark on the Trail of Tears.

"Dismalites" Add Glow to Canyon

After dark, the imaginative can hear the whispers of long-dead bandits who hid in Dismals Canyon's caves or the tears of the Chickasaw Indians held captive within its natural boundaries. But it is at night that the brave arrive to trek into the canyon to see something, perhaps, more rare than its ghosts.

By the glow of flashlights, visitors descend along wooden steps into the canyon. Crossing a swinging bridge, they enter a dark, cave-like area where outlaws once hid and turn off the lights. Soon, the crevice is illuminated by another light, the glow of dozens of miniscule creatures that live on the boulder walls.

Although the creatures known locally as Dismalites are "close cousins" of rare glowworms found in Australia and New Zealand, they are actually fly larvae related to fungus gnats, said Auburn University entomologist Gary Mullen, who has studied the insects.

Fungus gnats are found near mold, and the glowing insects are thought to be so plentiful in Dismals Canyon

because of the abundance of moisture and dark areas. The canyon is home to the largest known population of the glowing insects. On nights when conditions are right, the steep rock face looks like a star-filled sky. Best viewing times are May through September, although they are seen in smaller numbers year round.

The light comes from a chemical reaction in two pairs of light-producing structures in the larvae, one in the thorax and one near the tail end. The insects use the light to attract tiny flying insects in a sticky web-like substance.

Dismals Canyon is located at 901 Highway 8 in Phil Campbell, Alabama. For visitor information, visit dismalscanyon.com. Dismalite tours are conducted Friday and Saturday nights, with times depending on when night falls. Call (205) 993-4559 for information.

Turn Right When You Hit the Bottle

Every student heading from the north to the campus of Auburn University in southern Alabama has turned off Alabama Highway 280 onto Highway 147, which becomes College Street and takes motorists into the heart of downtown and the entrance of campus. What they may not know is that the corner of this intersection was once a famous landmark.

Strange Sites

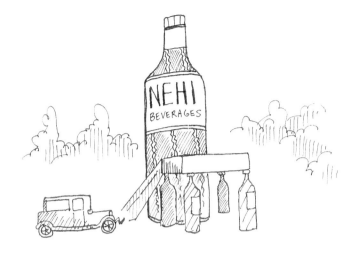

Margaret Bradley Ernest was eleven years old in 1924 when a man arrived at the family farm in Farmville, Alabama, to speak to her father, W.W. Bradley. The man had come to ask her father if he could use an outer parcel of his land for a building project. Bradley agreed.

"My father was just generous like that," Margaret recalled in May 2010, at age ninety-seven. "He just gave it to him. He never did get any rent on it."

The man was John F. Williams, owner of the Nehi Bottling Company in the adjacent town of Opelika, but Margaret knew him as "Chero-Cola" Williams after the company that owned Nehi products at that time.

What Williams proposed was unusual: he wanted to build the world's largest Nehi bottle at the intersection as a roadside advertisement.

Nehi Colas

The Nehi line of fruit-flavored soft drinks was introduced in 1924 by a company that sold Chero-Cola and was incorporated as Chero-Cola/Union Bottle Works. Nehi was offered in orange, grape, root beer, peach and other flavors. It became an instant hit, outselling its predecessor, Chero-Cola, leading the company to change its name to Nehi Corp. in 1928.

But then came the stock market crash of 1929, followed by the Great Depression. In 1931 and 1932, Nehi sales hit bottom, and the company lost money in 1932, the only year it did not make a profit.

In 1933, sales began to stabilize, and Nehi officials decided to reformulate their failed Chero-Cola and name it Royal Crown Cola, known across the South as RC Cola and often enjoyed with a MoonPie. It soon outsold Nehi, and the company again changed its name, this time to Royal Crown Cola Co.

The Bottle

When completed in 1924, the World's Largest Nehi Bottle was sixty-four feet high and measured forty-nine feet in diameter at the base and sixteen feet at the cap. It was built of wood, but Margaret recalls that it was covered in another material to make it appear shiny, like a bottle, and was painted a bright Nehi orange. The words "NEHI Beverages" were formed in large letters on its front.

The base of the bottle contained a gas station and country store. A second floor provided housing for the caretaker of the store.

Young Margaret did not think it odd to have a giant bottle structure within view of her home. "I just thought everybody had a bottle," she said with a laugh.

Margaret climbed inside the bottle often, making her way to the top. "The winding stairs would go to the top and you could remove the little cap and look out and see Opelika and Auburn," she said. The structure had no electricity, she said.

The corner became known as the Bottle, and tourists and locals would gather to eat and swap tales around a potbellied wooden stove.

It is rumored that President Franklin Delano Roosevelt, after his visit to Auburn University, spotted the Bottle and couldn't pass by without stopping. Roosevelt created the Civilian Conservation Corps in 1933, and two camps were located in Auburn, one of which created Chewacla State Park. However, the only visit of the president to the campus was recorded in 1939, after the Bottle's demise.

As Margaret grew, the bottle changed. At some point, her father built a small café attached to one side of the structure, and her aunt Hattie Bocsford Wilson, who was widowed, ran a barbecue stand from it and stayed in the quarters above the store.

Margaret, who was married by 1933, still lived on the family farm. Early one morning in 1933, she looked out a

window and saw the Bottle burning. "I went up the road to see if my aunt had gotten out," Margaret remembers. Her aunt had crawled from a window on the second level onto the roof that covered the gas pumps. "She jumped from there to a sheet people held beneath it." No one was injured, but as there was no fire department in Farmville at the time, the structure burned to the ground. Margaret believes the fire may have started in the barbecue pit.

The Nehi bottle was never rebuilt, but residents had grown accustomed to calling the corner the Bottle, and some still do today. Anyone who looks on a state map, or on Mapquest or Google maps, will see the name "The Bottle" written at the intersection of Highways 280 and 147.

Those who can find a retailer selling Nehi today can choose from flavors such as Blue Razberry, Chocolate, Lemonade, Strawberry, Blue Ice Cream and Watermelon, but in Auburn, Alabama, Orange Nehi remains most iconic.

THE EQUAL OPPORTUNITY CITY

In 1990, former Alabama governor George Wallace, famous for his anti-integration "stand in the schoolhouse door" in 1963, made another stand in the door. Trying in his later life to reverse his reputation as a segregationist, Wallace greeted former civil rights workers at the door of the church in a utopian city as they arrived to commemorate

the anniversary of the 1965 march to Montgomery. The anniversary was celebrated at the City of St. Jude, a community outside Montgomery created by a priest in the 1930s to aid the black population.

In 1965, despite the potential threat to development, St. Jude officials allowed marchers—who had been banned from staying at local hotels and other public buildings—to camp on the grounds of the community. A historical marker at the site reads:

> *On March 24, 1965, more than 25,000 marchers seeking voter rights and protected by St. Jude Thaddeus, the patron saint of hopeless causes and champion of impossible causes, rested overnight on the grounds. Public facilities were closed to freedom seekers. Father Paul J. Mullaney, director, The City of St. Jude, opened parish facilities for marchers. Joining them were celebrities including Harry Belafonte, Sammy Davis, Jr., Leonard Bernstein, Mahalia Jackson, Shelly Winters and other supporters.*

This support of civil rights would have been applauded by St. Jude's creator, Father Harold Purcell. The priest dreamed of a place where people could have access to church, school and medical facilities regardless of race. For many years, Montgomery's black citizens were treated at its hospital, attended its school, used its social center and received spiritual care in its Catholic church. St. Jude

instituted the county's first prenatal care program and developed the first drug and alcohol treatment center in the state.

The hospital also had the distinction of being the facility to attempt to save Viola Liuzzo, a white Michigan housewife who felt moved to join the civil rights movement in Montgomery and was shot by members of the Ku Klux Klan when the march ended. She died at St. Jude's hospital.

After aiding the civil rights workers, St. Jude experienced a sharp decrease in donations that almost caused its closure. The city survived, but the hospital closed in 1985.

Today, St. Jude continues operating a kindergarten-through-twelfth-grade Catholic school and a trade school, as well as providing healthcare to children with birth defects and who have mental or physical problems due to abuse.

Heaviest Corner on Earth

Birmingham was a fledgling city when the elements for making iron—iron ore, coke and limestone—were discovered within a small radius. An industrial boom began as furnaces and other industries were built. Birmingham earned its nickname, the Magic City, because of its incredible rate of growth at the turn of the century.

This growth led to a downtown boom that would make Birmingham Alabama's largest city and create the claim of

Strange Sites

the "Heaviest Corner on Earth." The area, which is now marked with a plaque, includes four large buildings at the intersection of the city's main streets, First Avenue North and Twentieth Street. They are: the ten-story Woodward building (now National Bank of Commerce) constructed in 1902 on the southwest corner; the sixteen-story Brown Marx building on the northeast corner; the sixteen-story Empire building constructed in 1909 on the northwest corner; and the twenty-one-story John A. Hand building constructed in 1912 on the southeast corner.

When construction of the Hand building was announced in *Jemison Magazine* in January 1911, the article had the headline: "Birmingham to Have the Heaviest Corner in the South." This headline was used to promote the area and soon was exaggerated to the "Heaviest Corner on Earth." The Woodward building was Birmingham's first steel-frame skyscraper and was built in the Chicago style of architecture.

In 1908, an addition to the Brown Marx building more than doubled its size. For many years, it remained the South's largest office building and had as its main tenant United States Steel Corporation.

A series of *E*s along the cornice of the Empire building, which now houses Colonial Bank, stood for the Empire Improvement Company, which built the tower.

The Hand building housed the American Trust and Savings Bank and later became the First National–John A. Hand building.

The buildings were added to the National Register of Historic Places in the 1980s. A marker was erected on May 23, 1985, by the Birmingham Historical Society and Operation New Birmingham.

"Eggbeater Jesus" a Huntsville Landmark

While it may seem disrespectful to some to refer to the famous mosaic adorning the outer wall of Huntsville's First Baptist Church as "the Eggbeater Jesus," it is said by local residents with affection. The nickname refers to the artist's rendering of Jesus with a seeming spinning of robes, which the church website calls an "obvious centrifugal motion."

Huntsville—home to the U.S. Space and Rocket Center and NASA's Marshall Space Flight Center—is called the Rocket City, and the massive artwork was created to represent a scripture referring to "a cosmic Christ." The mosaic, which has an "Age of Aquarius" appearance that many find ultra-contemporary for a southern church, has been a landmark in Huntsville since 1973 and also has the distinction of being one of the largest mosaics in the United States.

It cost $115,000 to complete. About fourteen million pieces of Italian tile no larger than a thumbnail were

Strange Sites

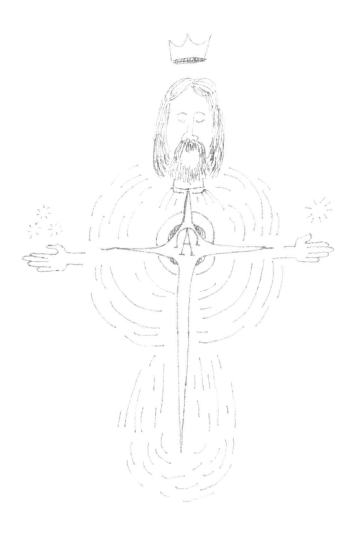

needed to create the artwork. After the design was laid out by artist Gordon Smith of Smith Stained Glass Studios in Fort Worth, Texas, each tile was painstakingly cut and hand painted by artisans at the studio. Finally, the tiles were brought to Huntsville and applied by the artist with his fingers or tweezers.

The Biblical significance of the number seven is portrayed repeatedly in the mosaic, so perhaps it is not coincidence that the artwork would take seven years to complete. It was first conceived in 1966, completed in 1973 and formally dedicated on January 13, 1974.

The seven arched bays of the roofline that provide cover for the artwork symbolize the seven trumpets of God heralding the coming of Christ in the book of Revelation. Seven outer doorways on the front of the sanctuary are an invitation to people to enter. In addition, Jesus holds seven stars in His right hand, and the seven churches are symbolized by balls of light with Christ at their center, representing his perfection.

The figure of Christ is forty-three feet high with a head more than five feet high. Each of Jesus' eyes is eight inches in diameter.

According to the church website at www.fbchsv.org, "The facade has been designed not only to capture the attention of the eye, but to issue a strong invitation to come inside the church."

Inside the sanctuary, stained-glass windows created by Smith Stained Glass Studios feature the same cosmic design. In addition, a forty-eight-bell carillon tower stands

beside the church building. The 229-foot steeple created by Campbellsville Industries Inc. is the largest prefabricated steeple in the world and was recognized in 1990 by *The Guinness Book of World Records*.

In January 2010, the church caught attention of a different kind when a tornado struck the Five Points district of Huntsville. No one was injured, but many homes were damaged. As the unusual white twister passed behind the spinning mosaic, Ryan Crim captured the image on film. The photo inspires so much awe that many believe it to be a fake, but several news sources, including the *Huntsville Times*, report the image to be real. It can be seen on the newspaper's website by visiting www.al.com and typing "First Baptist Church tornado" in the search bar.

First Baptist Church is located at 600 Governors Drive and is visible from South Memorial Parkway.

When Cave Clubs Were the Rage

During America's Prohibition era from 1920 to 1933, people were continually looking for places to drink illicit liquor. In Alabama, some of the best places to hide from the law were caves.

Three caves were reputed to have been used as nightclubs, and one became a famous nightclub years after Prohibition was repealed.

DeSoto Caverns

DeSoto Caverns was used as a nightclub in the 1920s and gained such a reputation for violence that it was called "The Bloody Bucket."

The cave was used during the Civil War to mine saltpeter, or calcium nitrate, which was used to make gunpowder desperately needed by the Confederate army. The army paid men up to fifty-nine cents per pound for saltpeter.

After the war, the cave was left empty until 1912, when Ida Mathis and a group of investors bought the cave for its abundant onyx. When options to mine the cave failed, Ida's son Allen bought the partners' interests, and the cave was once again left empty and available for illicit purposes.

In the 1920s, residents would come to the caverns for a little moonshine, some square dancing and perhaps some gambling. As is typically the case when drinking, gambling and carousing are combined, fights would break out. Before long, these fights resulted in shootings and various injuries, leading to the name "The Bloody Bucket." The cavern's reputation grew until law agencies heard of it and federal agents closed it.

In the early 1960s, Allen Mathis began to develop the caverns into a show cave, and it opened to the public in 1965. Also that year, University of Alabama archaeologists unearthed remains of a two-thousand-year-old Indian, which are now on display in the caverns.

Shelta Cave

Shelta Cave in Huntsville was purchased by the National Speleological Society (NSS) in 1967. NSS headquarters are located directly above the cave, which is currently open only to society members.

The cave is 2,500 feet long and has one of the most diverse ecosystems in North America. The NSS uses Shelta to study cave biology. Scientists have found nine unique species—three beetles, two crayfish, a shrimp and three other arthropods—in addition to other cave life.

However, before the cave was purchased for study and preservation, it was used as a party palace. Beginning in the late nineteenth century, before Prohibition began, Shelta Cave was the site of parties and underground boating. In 1888, according to newspaper accounts, local residents would descend by ladder thirty feet into the darkness of the cave and pay fifty cents to dance by candlelight.

The cave was closed for a time in the early twentieth century. On August 5, 1906, the *Atlanta Constitution* ran a story with the headline: "They Will Be Opened Again: Great Caverns at Huntsville Are to Be Given Electric Lights." Reportedly, the cave was again used as a dance hall during Prohibition.

Shelta Cave was placed on the National Registry for Natural Landmarks in 1971.

Bangor Cave

While some historians believe Bangor Cave in the Bangor community of Blount County was used as a speakeasy in the 1920s, it didn't gain widespread fame until 1937.

In that year, a fancy club and casino opened in the cave thirty miles north of Birmingham near where Interstate 65 is now located. It was billed as "America's Only Underground Nightclub." J. Breck Musgrove and investors lined the cave's floor with tiles, installed mahogany gaming tables and carved a bar and orchestra pit from stone.

People came from miles around to drink and dance beneath a ceiling painted to resemble the sky, but the casino, which was illegal, was located behind a locked door and open only to a special few with especially fat wallets.

Meals could be purchased for $1.10, and entertainment included Billy Yates and his Twelve-Piece Orchestra and various vaudeville acts. Patrons could bring their own drinks, or drinks could be purchased at the bar. Martinis were $0.35. A spur of the Louisville and Nashville Railroad that took patrons to Blount Springs would stop at the rural cave for $0.10.

When Governor Bibb Graves heard of the sinful goings-on, he included Bangor Cave on his list of "notorious dives" he wanted closed.

In August 1937, the Blount County newspaper reported a raid on the club: "Hitting with a bang that reverberated over the entire state, our new sheriff, Ed Miller, raided

Strange Sites

Bangor Cave on Saturday night just after the clock had passed the midnight hour and made a haul not only in gaming tables, but in arrests and drinks that make wild men wilder."

More raids would be required before the club finally closed in 1939. By then, the press had turned against the club. The *Southern Democrat* in Oneonta called it "a den of vice unequaled in Alabama."

Bangor Cave is still a popular destination, but those who come want to explore the cave and its history. Visitors can see the outline of the bar and the carved area that served as an orchestra pit.

NATION'S LAST RIVER POSTAL ROUTE

Magnolia Springs, as picturesque as its name implies, is a tiny burg in Baldwin County, Alabama, developed along the Magnolia River from a Spanish land grant in 1800.

After the Civil War, it was a popular destination for soldiers and their families—both Confederate and Union—who came to partake of its pure springs and enjoy its strategic location and lush scenery. In more recent history, the springs were tested by chemical companies, who proclaimed their waters "the purest in the world."

But Magnolia Springs has another claim to fame. Its postal service delivers its mail to residents along the river

by boat, and has since 1916. It is the only town in the continental United States that provides year-round mail delivery via river.

In her novel, *A Redbird Christmas*, novelist and Birmingham native Fannie Flagg bases her setting on Magnolia Springs, using as the backdrop for her story a small southern Alabama community where mail is delivered by boat.

Tiny Town Preserved for History

Despite the presence of paved streets and utility wires overhead, a visit to Mooresville, population fifty-six, is like a visit back in time. The entire town, incorporated by the Alabama Territorial Legislature in November 1818, is on the National Register of Historic Places. It is located near the Tennessee River in Limestone County, and its quiet streets are lined with two-hundred-year-old trees.

Don't mistake Mooresville for a museum—it is an operational town with a town council and mayor and residents living in its historic homes. The village includes several historical buildings, and one of the most important is Mooresville Post Office. Built about 1840 of sawmill lumber, the building at the corner of Lauderdale and High Streets is still an operating post office, the oldest in the state.

The Stagecoach Inn and Tavern was built about 1821 and is the oldest public frame building in the state. The

Strange Sites

bottom floor of the two-story building was a tavern and includes a restored fireplace. Upstairs were guest rooms used by travelers from the river or along the route from Birmingham to Nashville. It is now a museum.

The town also includes two historic churches: one known simply as the Brick Church, built in 1839, and the circa 1854 clapboard Church of Christ. The Brick Church is one of the few remaining examples of the Greek Revival brick churches built in the early nineteenth century. In addition, the presiding pastor in 1870 was Constantine Blackman Sanders, known as the "X+Y=Z" preacher or the "Sleeping Preacher," who made predictions and healed the sick while in a trance.

Before he was president, General James A. Garfield was encamped near Mooresville during the Civil War and preached at the Church of Christ. It continues to operate under the Church of Christ denomination.

In 1995, Disney and producers of the film *Tom and Huck* covered the paved streets with dirt and used the town as a nineteenth-century village setting. The film starred Jonathan Taylor Thomas as Tom Sawyer and Brad Renfro as Huckleberry Finn.

Those planning to visit Mooresville should know:

- Each December, residents decorate the entire town with fresh greenery.
- The Historic Mooresville Home and Garden Tour is held in May of odd-numbered years.

- Limestone Bay Trading Co. Restaurant opened in February 2004 in the old general store location.

For more information, visit mooresvillealabama.com.

World's Largest…Traffic Beacon?

Most people in Alabama have heard of the Vulcan, the statue in Birmingham honoring the god of the forge. But what some may not know is the story behind the popsicle-shaped beacon the Vulcan held for half a century.

The statue of Vulcan is 56 feet tall from his toes to the tip of his spear and sits on a 124-foot pedestal. He weighs 101,200 pounds, which is about as much as forty-one Honda Civics. In addition to being the largest cast-iron statue in the world, Vulcan was once touted as the largest metal statue ever cast in the United States, although recent competition has put that claim into doubt.

He was built by sculptor Giuseppe Moretti to show at the 1904 World's Fair in St. Louis. Initially, when the fair ended, Vulcan did not have a home. He would be sold to the highest-bidding city. What better place to locate the world's largest cast-iron statue than the city of Birmingham, the only place in the world where the ingredients needed to make iron—iron ore, coal and limestone—are located in proximity?

Strange Sites

Birmingham leaders decided to place him temporarily at the Alabama State Fairgrounds, where he was assembled incorrectly—his right hand was backward—and where he stayed for more than thirty years.

He had become more of a joke than an icon, being used by local advertisers who placed a giant ice cream cone and a Coke bottle in his outstretched hand. The final insult came when he was dressed in a large pair of Liberty overalls. Deciding enough was enough, a group raised funds to build a park atop Red Mountain, where Vulcan would be the centerpiece. He finally arrived in 1939.

It was in 1946 that the safety committee of the Birmingham Jaycees decided to make Vulcan the poster boy for highway safety. A huge cone-shaped beacon was placed in his hand, where it was supposed to remain during a six-month safety campaign. The beacon shone green unless someone was killed on Birmingham's highways; then it glowed a bright red and was visible throughout the city, giving testimony to the need for caution on the roads. The beacon stayed for more than fifty years.

When Vulcan was renovated in 1999, the torch was removed as part of efforts to bring Vulcan back to the vision Moretti intended. The torch is now on display in Vulcan Center at the park, and visitors can push a button to make the light shine green. Because Vulcan's spear point was never returned from the 1904 World's Fair, a new one was created and placed into his outstretched hand. The restored statue was unveiled in 2003. For the first time in ninety-nine years, Vulcan stood as he had during his debut in St. Louis.

Tribute to a Tragic Romance

Theirs was a tragic love story fit for a novel. In many ways, the story of F. Scott Fitzgerald and Zelda Sayre Fitzgerald *was* novelized, as both writers used portions of their real-life marriage in their books. The story of the cosmopolitan writers and their demons—his alcoholism, her mental illness—was well publicized. What some people may not know is that the couple spent their last year living as a couple in Montgomery, Alabama.

In 1931, Scott and Zelda, who was born in Montgomery, shunned life in New York, Paris and Hollywood and decided to move to Alabama's capital city with their daughter, Scottie, who was nine at the time. Seeking a life away from the limelight created by Scott's novels such as *The Great Gatsby*, the family lived in a two-story brown home at 819 Felder Street (later renumbered to 919 Felder Street). From all accounts, the family was initially happy, playing tennis and visiting old friends. Zelda intended to work on her first novel, *Save Me the Waltz*, and Scott was writing *Tender Is the Night*.

But an entry in Scott's journal showed he had begun missing the limelight. It said simply, "Life dull." Within months, he went to Hollywood to work on a movie script, leaving Zelda and Scottie behind. Not long after, Zelda was hospitalized for her ongoing mental problems, and Scottie stayed with her grandmother in Montgomery until the school year ended in 1932. While at the clinic in Maryland,

Zelda completed *Save Me the Waltz*, which was published in 1932. Both *Waltz* and *Tender Is the Night* drew on the couple's real-life marital troubles. The name of the protagonist in Zelda's novel was Alabama Beggs.

Zelda and Scott never again lived together, although they never divorced. Scott had not seen his wife for more than eighteen months when he died in Hollywood in 1940 at the age of forty-four.

Zelda entered Highland Mental Hospital in Asheville, North Carolina, in 1936 and began work on a second novel that was never completed. She spent the next several years in and out of the hospital in Asheville and was a patient there in 1948 when fire broke out, killing Zelda and eight other women. She was forty-seven.

The couple is buried in St. Mary's Catholic Cemetery in Rockville, Maryland. Their joint headstone is inscribed with the final line from *The Great Gatsby*: "So we beat on, boats against the current, borne back ceaselessly into the past."

Their former Montgomery home was to be demolished in 1986 when it was purchased by a couple who lived on the street to maintain as a museum. At that time, Scottie Fitzgerald Smith was living in Montgomery, having moved back in 1973. The new owners of the home, Julian and Leslie McPhillips, asked if she would like to participate in creating the museum. Scottie stated that she supported the idea of the museum but declined to assist in the endeavor. She died in 1986 of cancer at the age of sixty-four.

Scottie, a journalist, was later inducted into the Alabama Women's Hall of Fame for her contributions as a writer for *Time*, the *New Yorker*, the *New York Times*, the *Washington Post*, the *Democratic Digest* and the *Northern Virginia Sun*.

She also wrote three books: *Don't Quote Me*, which she co-wrote about women of the media; *The Romantic Egotists*, about her parents; and *An Alabama Journal 1977*. After a battle with some residents who felt a museum would draw too much traffic to the area, the F. Scott and Zelda Fitzgerald Museum opened to the public in 1989 and is today the only museum honoring the doomed literary couple F. Scott and Zelda Fitzgerald.

The museum contains many articles from the couple's lives, including photos, letters, copies of their novels, prints of Zelda's artwork and more.

COUNTRY'S FIRST GRAFFITI ETCHED IN STONE

In the early 1700s, traders traveled to Indian villages to act as merchants and political ambassadors between the European nations and the Indians. One early route, known as the Charleston-Chickasaw, passed the cave now known as DeSoto Caverns in Childersburg, Alabama. In 1723, Charleston trader and landowner I.W. Wright, who was on a trip to the nearby Creek towns of Abihka and Coosa,

stopped at the cave to rest. While there, he carved his name and the year in a stone. Legend says the Indians, angry at this intrusion, scalped him. A few years later, an explorer reported in his journal that a skeleton was found near the stone carved with Wright's name.

Whether Wright was killed for his infraction—which would also make his the earliest, and perhaps deadliest, punishment for vandalism—the existence of the carving is not in doubt. It is on display at the caverns and touted as the oldest cave graffiti in the country. Not only that, but brochures and advertising also claim that DeSoto Caverns is the oldest recorded cave in American history.

After George Washington was elected the nation's first president on April 30, 1789, he appointed Benjamin Hawkins as agent to the Creek Indians. Hawkins also was general superintendent to all native tribes south of the Ohio River. In this capacity, he visited the Upper Creek territory in 1796 and sent a report to Washington on his travels. He had visited DeSoto Caverns and described its natural beauty to the president, making it the first officially recorded cave in the newly formed United States.

These claims are not so surprising considering Childersburg, the city where the caverns are located, purports to have been settled before any other U.S. city. Historians note that the arrival of Hernando DeSoto and his Spanish expedition in 1540 makes Childersburg the oldest continuously occupied settlement in the United States, beating St. Augustine, Florida, by twenty-five years.

DeSoto Caverns is located at 5181 DeSoto Caverns Parkway in Childersburg, Alabama. It is open varying hours, depending on the season. For information, call (800) 933-2283 or e-mail info@DeSotoCavernsPark.com.

AUNT EUNICE LIVES ON IN CAFÉ MUSEUM

Everyone adored her. Politicians honored her. Celebrities came to visit her. And everyone—from senators and astronauts to athletes and musicians—was expected to earn his lunch by doing a little work. The rule at Aunt Eunice's Country Kitchen in Huntsville, Alabama, was simple: you were expected to get up and get the pot to refill your own coffee cup, and while you were at it, you should kindly refill the cup of anyone else who might need it.

Aunt Eunice's was a homey, humble downtown eatery that served breakfast and lunch to people from all walks of life for more than fifty years. Its proprietor, Eunice Merrill, was a beloved icon who was recognized in the *Congressional Record*, on national television and in famed southern humorist Lewis Grizzard's writings. She was mourned throughout the South on her death in 2004.

Today, visitors to Huntsville can view what is believed to be the only museum to a restaurant proprietor in the state of Alabama. Aunt Eunice's Country Kitchen was re-

created on the grounds of the Huntsville Depot Museum on Church Street, with its cracked vinyl booth seats, signed photos of celebrities, worn coffee pots and the well-known Liar's Table, where local, state and national politicians routinely sat to eat Aunt Eunice's famous biscuits and country ham with redeye gravy. Her visitors included everyone from former Alabama Governor George Wallace to famed athlete Bo Jackson.

Upon Aunt Eunice's death on February 17, 2004, at the age of eighty-four, the Alabama legislature read into record House Resolution 218, which stated: "Be it resolved by the House of Representatives of the Legislature of Alabama that even as we mourn the death of Mrs. Eunice Isabell Jenkins Merrell, we give thanks for her life of service and extend deepest sympathy to her family, for whom a copy of this resolution shall be provided that they may know of our shared sorrow in their great loss."

The resolution included details of Eunice's humble beginnings and noted her service to the community, particularly her fundraising efforts for the Arthritis Foundation.

Eunice Isabell Jenkins was born in 1919 one of twelve children—she had six brothers and five sisters—to Madison County cotton farmer and part-time minister Joseph Franklin Jenkins. She reportedly said the family was so poor "we couldn't afford to pay attention."

In 1940, she married Leonard Merrill, and they had three children. To help pay the bills, Eunice worked odd

jobs, including a stint at her brother-in-law's café. She decided to open her own place, and with a borrowed seventy-five dollars, she set up the Butler Café across from Butler High School. She moved to the Andrew Jackson Way location in 1952, and that's where the restaurant stayed until her death.

So beloved was Eunice that the entire population of Huntsville was shocked and outraged when Eunice was attacked on October 19, 1995, by a father-and-son team of robbers. Eunice was left for dead but managed to get help. She was hospitalized, and news crews covered the story for weeks. Residents flooded the Madison County district attorney's office with calls demanding justice for Aunt Eunice. The attackers were caught, and the seventy-four-year-old Eunice was back at her restaurant within a few days.

The resolution read on her death nine years later gave Eunice's motto, saying she "attributed the restaurant's longevity to treating people right." She had a hug and a smile for everyone who visited, but what people often came away with was some of her famous biscuits.

Aunt Eunice's Biscuits

2 cups White Lily self-rising soft wheat flour
¼ cup Crisco vegetable shortening
About ¾ cup milk

Preheat oven to 500 degrees. Place flour in mixing bowl. With fork, mix in shortening until the mixture looks like crumbs. Blend in enough milk with the fork until the dough pulls away from the side of the bowl. Place dough onto lightly floured surface and knead gently, about ten turns.

Roll out dough to ½-inch thick. Cut biscuit rounds with small empty can or glass. Place an inch apart on ungreased baking sheet and bake 8 to 10 minutes.

Makes 12 biscuits.

Part III

Intriguing Incidents

WHEN AXE MURDERERS TERRORIZED BIRMINGHAM

Immigrants living in Birmingham in the early 1920s had reason to lock their doors at night and tremble beneath their blankets. Killers were on the loose, chopping people to death with axes and sometimes meat cleavers—and many of the victims had foreign surnames. The spree would continue for four long years, from late 1919 to early 1924.

The number of victims varies in newspaper accounts of the time, from sixteen to as many as forty-four. Others survived the attacks, but barely. The majority of the attacks were carried out on merchants in outlying parts of the city.

They were assaulted in their shops, and afterward, their money and merchandise were stolen.

Authorities believed the attacks to be too brutal and widespread for them to have been committed by one person. This was a group serial killing.

The attacks began on November 28, 1919, when G.T. Ary was chopped to death with an axe while in his shop. Less than a month later, on Christmas Eve, John Belser would die in a similar manner. The bloody assaults did not discriminate by age or gender—men, women and even children were among victims of the axe.

Here are a few of the victims whose names were recorded in newspapers:

- J.J. Whittle was wounded in his shop on March 5, 1921.
- Charles Baldone, his wife and daughter were wounded on July 13.
- H.I. Dorsky was wounded on August 17.
- Mrs. Sam Zideman was left for dead in her family's shop on September 6, but she survived.
- Joseph Mantione and his wife were killed on December 21.
- On that same day, a black man named Mose Parker was killed with an axe, but authorities are not sure if his murder was by the same group or a copycat.
- Clem Crawford and his wife were butchered on January 11, 1922.
- Tony and Rosa Lomio were attacked later that month in their shop but survived.

Intriguing Incidents

- On June 3, three members of the Lucia family were attacked. One died.
- J.H. Seay was wounded on September 30.
- Abraham Levine was slaughtered on November 6. His wife was injured.
- On January 10, 1923, Joseph Klein was killed and his daughter wounded.
- Luigi and Josephine Vitellaro were killed later that month in their store.
- Charles Graffeo was murdered on May 28, 1923. The next day, the *Reading Eagle* in Pennsylvania reported: "Graffeo was found dead at his store in an outlying residential section last night with his skull crushed by the blow of an axe and his throat slashed. A blood-spattered axe stood behind the door. Its handle was shortened so that it could be carried beneath a coat, police believe."
- Elizabeth Romeo and Juliet Vigilante were among the last victims on October 22, 1923. The *Miami News-Metropolis* reported the attack in an Associated Press story: "The assailant of the two women used a meat cleaver. Six dollars was removed from a cash register, police reported, after the attack. It was said at a hospital where Mrs. Vigilante was removed that her wounds were of a most serious nature."

Within a few months, the bloody spree would come to an end. Birmingham police arrested five suspects in January

1924. The suspects were black, and four were men: Peyton Johnson, O'Delle Jackson, John Reed and Fred Glover. It is unclear if a fifth suspect, named Pearl Jackson, was male or female.

The group confessed to participating in eight of the unsolved murders. Their arrests were reported in newspapers across the country, sparking controversy after the initial confessions were obtained using a "truth serum" called scopolamine. The confessions were later obtained without use of drugs.

On January 28, 1924, the *Atlanta Constitution* blared the headline: "Drug Forces Confessions in 44 Ax-Murder Cases." The story stated: "Birmingham's 'ax murder' wave is believed by Solicitor James G. Davis, of the Jefferson County circuit court, to be at an end with the arrest of five persons who have, according to this official, made signed confessions."

On February 25, 1924, the *Pittsburgh Press* published an International News Service story about the use of truth serum. The article stated: "For three years, Alabama officers, aided by the best detective talent of the country, have made desperate attempts to break up the gang of marauders whom that hold guilty of the ax crimes."

Davis's response was quoted: "It took the truth serum to bring the activities of this murder syndicate to light." Authorities discovered the five were members of a syndicate whose motive was robbery. One newspaper reported they would draw straws to see who would have

the honor of committing the next murder. The suspects were convicted. Although Davis said three members of the gang were believed to remain at large, the spree was finally over.

Reno Had Nothing on Alabama

While Reno, Nevada, is well known as a place to obtain quickie divorces, most people likely don't realize Alabama was once home to a divorce mill that proved quite profitable—at least for the attorneys. Thousands of celebrities and socialites came to Alabama over the course of twenty-five years, where they could bypass residency laws and get divorces in as little as a few hours.

In August 1970, two Alabama circuit court judges and seven others were indicted for taking part in a quickie divorce scam. By then, Alabama had been a destination for quickie divorces since 1945, but over the years, state legislators and bar officials would make efforts to stop—or at least slow—the practice.

The lucrative practice of providing quickie divorces began when a law was abolished requiring a one-year residency before partners could divorce in Alabama. Suddenly, people could find dozens of attorneys throughout the state who would perjure themselves by claiming their clients were residents, even if they had arrived by plane

from New York mere hours before. Nevada was thought to be the most liberal divorce law state, requiring only six weeks' residency. But why live in Nevada for six weeks if you could divorce in Alabama without even spending a night?

In 1962, *Time* magazine wrote an article called "Alabamy Unbound" about the divorce phenomenon and stated that the divorces in Alabama outnumbered those in Reno at that time. The reporter wrote:

> *But in recent years, Nevada's divorce rate has fallen consistently. In fact, there has been such a drop in tabloid-fodder divorces that the* New York Daily News *has decided to close down its Reno bureau. The fact is that for several years now, the easiest divorce terms in the nation are to be found not in Nevada but in*

Intriguing Incidents

> *Alabama. A divorce seeker need show up in Alabama only long enough to meet a lawyer, pay a fee, fill out the papers and wait a few hours. The lawyer shoots off usually to a rural county, hires a local lawyer to handle the court work, gets a decree and hops back to his client.*

Divorces became goldmines. In 1960, Alabama granted more than 17,000 divorces, while Nevada only filed 9,274.

One person who obtained his divorce in Alabama was John Daly, the host of the game show *What's My Line?* and former vice-president of ABC. On December 22, 1960, he married Virginia Warren, daughter of Chief Justice Earl Warren. He was only able to do this after divorcing his first wife, Margaret Neal, in Luverne, a city in Crenshaw County, Alabama.

Another famous divorce was that of cartoonist Charles Addams, who created the Addams Family cartoons for the *New Yorker* magazine. The comics later were developed into a television series of the same name. In 1954, Addams married his second wife, Estelle B. Barb, who went by the name "Barbara Barb." Barb, a Morticia lookalike, was known as a shrewd attorney, which was proven when she eventually obtained control of the *Addams Family* television series and movie franchises. The couple divorced in 1956 after Barb came to Limestone County, Alabama, "established" residence in a day or so and left.

Former matinee idol Conrad Nagel also obtained a divorce in Limestone County.

The most famous of the Alabama divorces was that of Athina Mary Livanos Onassis Spencer-Churchill Niarchos, or "Tina," the daughter of Greek shipping magnate Stavros Livanos. Tina divorced her husband, Aristotle Onassis, in Washington County, Alabama, in 1960, reportedly after she discovered her husband having sex on their yacht with the opera singer Maria Callas. Tina and Artistotle had two children: Alexander, who died in 1973, and Christina, who died in 1988. Her son's death in a plane crash led to Tina's suicide. By then, Aristotle had married again, to Jacqueline Bouvier Kennedy.

Others who divorced in Alabama included Grace Metalious, author of *Peyton Place*, and Lady Iris Mountbatten.

The 1962 *Time* article stated:

> *In fact, the state has won such repute as a divorce mill (as well as a place that goes easy on minor perjuries), that a group of embarrassed jurists has been trying vainly to get the old one-year, residency requirement reinstated. There is some doubt that the law will be changed, however. The divorce business is bringing a lot of money into Alabama, even though the lawyers (who average $250 on an ordinary case) get most of the take.*

A 1961 effort to reinstate the year's residency requirement failed to pass the legislature, but the Bar Commission of Alabama added to its code of ethics a section prohibiting

attorneys from taking part in divorces "with knowledge of reasonable cause to believe that neither party…is at the time of filing the complaint…a bona fide resident" of the state, according to an article in the *Tuscaloosa News* in 1970.

By 1967, the practice had slowed, and attorneys apparently were adhering to the code of ethics—except for those in Geneva County, where quickie divorces were flourishing and seven officials were eventually indicted.

Several attorneys were disbarred after it was found they continued to create fake residences for out-of-state clients who wanted to divorce. The attorneys were indicted after investigators determined they continued to pass themselves off as attorneys and, with assistance of two judges, continued to provide divorces and used the U.S. Postal Service during their schemes. They were convicted of mail fraud, and quickie divorces came to an end in Alabama.

The Birmingham Church Panic of 1902

Annie Bradford was among the thousands of people who came to Shiloh Baptist Church in Birmingham on September 19, 1902, to see the famed Booker T. Washington speak. Before the night was over, tragedy would strike, and Annie would narrowly escape with her life.

She was among the lucky ones—115 people would die that day in what became known as the Birmingham Church Panic.

Later, Annie described the scene in a book called *The Trumpet's Blast*:

> *We helped to form a second layer of fallen people are as we piled up with, it seemed, hundreds piled upon us. It was utterly impossible to move or get out…I was lying fastened down tight on a little thin woman and a big fat man. The woman was quite still—I don't know whether she was dead or not: The man kept trying to get out but couldn't. I noticed the police pull a dead woman from on top of me. The man I was lying with asked for a drink of water. A man brought the water and gave it to him, and gave me some, too. I think the water saved both of us. I was so hot that it seemed I would burn up.*

Annie would spend a week in bed recovering from her injuries. Others, too, would recover from injuries sustained during the panic, but still more would not survive the crush of people caused when people mistakenly thought someone yelled "Fire!"

The evening began with an immense feeling of pride among Birmingham's black Baptists. They were proud to be hosting the National Convention of Negro Baptists in a stately modern church building with a capacity of as

Intriguing Incidents

many as three thousand people. It had been completed in 1901. Not only that, but Washington, founder of the renowned Tuskegee Institute, had agreed to speak. Birmingham was buzzing.

Robert Henry Walker Jr. would later write *The Trumpet's Blast* to commemorate the tragic events of that night. He wrote: "Thousands of people who, probably, would not have left their homes that night, were out at Shiloh Church. Hundreds to get a glimpse of the great man; hundreds to hear what he had to say; hundreds curiosity seeking; and hundreds drawn by the natural trend of circumstances without any particular motive."

By the time the speech began, the church was filled beyond capacity, with people standing in back of the sanctuary. It had grown uncomfortably warm in the filled room. Washington's speech, just half a century after the Civil War, focused on how black Alabamians could further the cause of equality. "The sooner we can grow to the point where all races in all sections of the country will recognize and agree to the fact that the Negro is a permanent part of American citizenship…the better it will be for all parties concerned. Nothing will be permanently gained for either race by the one throwing stones at the other or by doing that which will engender strife, and create and keep alive suspicion," Washington told the crowd.

Soon, a minor squabble would lead to chaos. Witnesses agreed that within seconds of the conclusion of the speech, two people had a dispute over a chair on the podium, and

it looked as if they would fight. Someone yelled "Fight!" A pastor began to yell "Quiet!" To the hot, closed-in crowd, it sounded as if someone were yelling "Fire!"

People began to rush to the doors at the front of the sanctuary. Shouts of "There is no fire!" were confused with "There is a fire," and the panic escalated.

An usher, John Bunn, attempted to calm the mob, to no avail. Later, he would write:

> *One of the most appalling scenes that met my gaze was a little girl, who in that terrible stampede began screaming "Murder! Murder!" I looked and saw her. She was being squeezed to death, I thought. Once more, I plunged into the crowd but failed to get her all the way out; myself having been pushed and mashed. I had to turn away. My last glance saw her still in the crowd, wedged as tight as wax. I thought she was killed but two days later a lady stopped me on the street, addressed me by my name and said: "Mr. Bunn, you saved my daughter."*

Newspaper headlines soon would tell the grisly details. The *New York Times* reported on September 20

> *Dead bodies were strewn in every direction, and the ambulance service of the city was utterly unable to move them until long after midnight. While the injured were being attended to dozens of dead bodies were arranged*

> *in rows on the ground outside the building awaiting removal to the various undertaking establishments, and more than a score were laid out on the benches inside… The sight which greeted those who had come to aid the injured was sickening. Down the aisles and along the outside of the pews the dead bodies of men and women were strewn, and the crippled uttered heartrending cries. The work of removing the bodies was begun at once.*

Like many others not in attendance who heard of the tragedy, Ora Bell Nolums walked from her home to the church hoping to determine if any of her family or friends had been injured: "The sight was terrible…The dead died in all kinds of shapes. Some with necks broken and nearly everything else one could imagine. One man's fist was jammed down in his own throat up to his waist and his mouth was bleeding."

In its September 21 edition, the *New York Times* would describe another injury:

> *Policeman Elledge, who was standing at the exit, endeavoring to quiet the mad throng, was caught between the moving multitude and the wall in a narrow passageway. His legs were crushed, but he will recover. His efforts to quiet the crowd were utterly futile, and not until the Fire Department and a large number of officers arrived on the scene was anything like order restored.*

Some described piles of bodies at the doors of the church as being eight feet in depth. Most of the victims suffocated. Washington, who was at the front of the church, was unharmed, but historians report that the disaster would haunt him until his death.

THE ALABAMA COFFIN PROTEST

In March 1965, at the height of the civil rights movement, ten black-draped coffins were left near the steps of Alabama's capitol building. The empty coffins were a silent protest against Governor George Wallace, who at the time was a segregationist who made the famous "stand in the schoolhouse door" in 1963 and had to be forced by federal agents to allow black students to enter the University of Alabama.

The caskets, which represented the number of people killed in 1963 and 1964 in the fight for civil rights, were carried to the capitol steps by black and white people.

The protestors had just come from a memorial service for Viola Liuzzo, who was shot and killed after the march to Montgomery.

Liuzzo was a white mother of five from Michigan who came south after seeing images of Bloody Sunday, the aborted march that began March 7 on the Edmund

Intriguing Incidents

Pettus Bridge in Selma. Upset by the carnage, Liuzzo left her children with her husband and joined the march. When it ended on March 25, Liuzzo offered rides home to local marchers in her 1963 Oldsmobile. Leroy Moton, a nineteen-year-old African American, rode with Liuzzo.

Liuzzo and Moton were the only two occupants of the car as it drove along Route 80 when a car carrying four Klan members came alongside the Oldsmobile. Someone shot into the car, hitting Liuzzo twice in the head and killing her instantly. Her car crashed into a ditch. Moton, who was covered in Liuzzo's blood but was not hit, was left for dead.

A funeral service was held March 30 at Immaculate Heart of Mary Catholic Church in Detroit. Mourners included Dr. Martin Luther King Jr. and Teamsters president Jimmy Hoffa. Within days, a charred cross was found in front of the Liuzzos' home and at those of three other Detroit residents.

Four people were arrested in the shooting: Collie Wilkins, FBI informant Gary Rowe, William Eaton and Eugene Thomas.

The coffin protest following the memorial for Liuzzo was made on the same day Wallace took his first steps toward ending the bloodshed by meeting with civil rights workers.

According to a story in the *Age* in Melbourne, Australia, on April 1, 1965: "It was his first such meeting as governor and, after the 80-minute conference, both sides said the meeting was 'friendly.'"

The day before the coffin protest, the U.S. House of Representatives Committee on Un-American Activities began an investigation into actions by the Ku Klux Klan.

The Fight to Protect Hal's Kingdom

An isolated wilderness area in the southernmost part of Clarke County, where the Alabama and Tombigbee Rivers meet, is the origin of a little-known tale about an escaped slave, the community he created and his battle to stay free.

The story of Hal's Kingdom is lacking in some details because few documents survive recording the events. Much of what is known is passed down through oral history, and some details conflict. What remains at the core is a tale of survival.

Even the date is lost to time, but the events occurred in the first half of the nineteenth century. The man at the center of the tale is Hal, the slave of Colonel Alexandre Hollinger of Poll Bayou. Records do exist of Hollinger, who was born January 27, 1793, in Mobile. He married Sally Carson, the daughter of Colonel Joseph Carson who was known as the "Belle of the Bigbee." The couple had two children, but Sally died when they were infants and they were raised by relatives. Hollinger would later marry Tabitha Moore and have two more children. Hollinger was known for his bravery. He was wounded

Intriguing Incidents

at the Battle of Burnt Corn in 1813 while fighting the Creek Indians.

According to local lore, the Hollinger family had moved to Claiborne, and Hal escaped while on a trip with his master. Hal reportedly took his enslaved wife and other slaves with him, and they settled in the desolate, swampy wilderness of Clarke County where, even today, wildlife is plentiful and deer, alligator, bears and large game could be hunted for food. The slaves built cabins and survived by killing game and rafting downriver to Mobile to sell hides. For many years, the colony went undetected. The number of slaves who escaped and came there to live grew.

Hal was the obvious ruler of the colony that soon became known as Hal's Kingdom. The escapees used money from the sale of hides to buy guns and ammunition to protect their colony.

After so many years of anonymity, some of the slaves began to grow bold. Plantation owners began reporting thefts of food and cattle. A group of settlers, determined to stop the thieving, posted guards at night in an effort to catch someone in the act. Soon, they caught a man named Joe, who was forced to show the whereabouts of the hidden colony.

The settlers couldn't know that Hal and his subjects were prepared for an attack. From behind a log stockade, the former slaves defended their territory. A fierce battle ensued.

A reference found in a July 12, 1827 edition of the *National Gazette and Literary Register* in Philadelphia may be

one of the few remaining written records of the incident. The newspaper article stated:

> *A nest of runaway negroes was discovered last week in the fork of the Alabama and Tombeckbee* [sic] *Rivers, by a party from the upper end of Mobile County, consisting of Messrs. Dupree, Joseph Johnson, John Johnson, Rain Reaves and some others. The negroes were attacked and after a very severe action they were conquered. Three negroes were shot,* viz: Bust, Hector and Hal; *several were taken prisoners, and others escaped. They had two cabins and were about to build a Fort. The encampment is probably broken up entirely. Some of these negroes have been runaway several years, and have committed many depredations on the neighboring plantations. They fought desperately.*

An article written by Kerry Reid and researchers at the Clarke County Historical Museum states that historians are newly interested in the tale of Hal's Kingdom. "Hal still remains a hero of antebellum days. He was a famous freedom fighter."

Because of this legend, historians believe the area could also have been a stop along the slave escape route, the Underground Railroad.

The Clarke County Museum is housed in the Alston-Cobb Home at 116 West Cobb Street in Grove Hill, Alabama.

Meteorite over Sylacauga

Perhaps it was prophetic that the Hodges family of Sylacauga lived down the street from the Comet Drive-In. In 1954, Ann Hodges was taking an afternoon nap on her sofa when she was awakened by an object striking her, leaving bruises on her hand and hip. It as an 8.5-pound meteorite.

That day, Hodges became the only known person to be struck by a falling star. The meteorite was estimated to be traveling several hundred miles per hour.

Hodges would eventually donate the rock to the University of Alabama's Museum of Natural History in Tuscaloosa in 1956 to avoid the ensuing chaos. Hodges endured an Air Force investigation, repeated attempts to buy the rock and a flurry of media attention before washing her hands of the meteorite.

According to witnesses quoted in newspapers at the time, people from Georgia to Mississippi reported seeing a strange light in the sky near the time Hodges was struck. Experts say meteorites produce a sonic boom when entering the atmosphere, traveling many times the speed of sound.

Officials from Maxwell Air Force Base confiscated Hodges's meteorite and took it to Wright-Patterson Air Force Base in Ohio but later returned it to Hodges.

Hodges couldn't relax for long. The landlord of the home she lived in with her husband sued the couple for

possession of the rock. The suit was settled out of court, giving possession to Hodges.

The original rock is kept under glass at the museum in Tuscaloosa, where visitors can see a stain of tar from the Hodgeses' roof. The rock is on display in Smith Hall on Sixth Avenue near the Quad on the University of Alabama campus.

MINE TRAGEDY A LESSON IN VALUE OF LIFE

In 1911, an explosion inside a mine near Birmingham not only would bring attention to the dangers of coal mining, but it would also call into question the practice of leasing convicts for the dangerous work. It would cause the largest loss of life in a mine accident in Alabama until that time. The state already had a frightening safety record: one thousand people died in mines from 1900 to 1910.

On April 8, a massive explosion rocked the Banner Coal Mine at Littleton, owned by the Pratt Consolidated Coal Company, killing 128 miners. Of those who died, 125 were convicts leased to the mining company from state prisons.

The *Atlanta Constitution* reported on April 10: "The entire state board of convict inspectors is on the scene, consisting of James Oakley, president, Dr. W.A. Burns and Hugh M. Wilson. They will make a detailed report on the disaster

to Governor O'Neal. Of the 128 men in the mines before the rescue work stated five were free—two whites and three negroes—123 were convicts, twelve of whom were white."

Begun in 1866, leasing prisoners was a common practice of industries and businesses at the time. But this and previous disasters led to debate on the topic within the state legislature. The practice financially benefited mine owners and the state, so reform of the law had been difficult to pass. But lawmakers could not deny the great loss of life at Banner.

O'Neal supported reform and used the tragedy to help push through stricter mine safety regulations. However, the convict lease system continued until 1928, when it was outlawed.

The investigation into the cause of the disaster revealed: "Inspector Robert Neill found that 'the explosion originated by a premature explosion of bituminite,' aided probably by dust. Imperfect ventilation, he thinks, could not have caused the explosion," the *Atlanta Constitution* reported on April 23.

Other deadly Alabama mine disasters in the first decade of the twentieth century include:

- Virginia Mine tragedy, February 1905. This explosion killed 112 workers, but many died from flooding caused when the blast demolished water pipes inside the mine near Bessemer.

 The *Fort Worth Telegram* in Texas reported in 1905: "It is therefore possible not a few of the men were

drowned, as several bodies have been seen floating around in the flooded rooms…In very many instances it is impossible to identify the corpses, they are so badly blackened and mangled. Absolutely no hope is held out now of finding anyone alive in the mine, especially in view of the discovery that many of the rooms have been flooded."

The *Birmingham Ledger* reported on February 22, 1905: "Only Sons are Among the Dead: Terrible Loss of Mr. and Mrs. P.J. Powell." On February 24, the *Birmingham Age-Herald* wrote: "One Miner was Found on Knees in Prayer."

- Yolande Mine explosion, December 1907. This explosion near Tuscaloosa killed ninety-one miners. The *New York Times* reported on December 17: "Within an hour after the explosion seventeen men had crawled out of the mine, all burned. Thirty-five dead bodies had been recovered up to dark." The *Birmingham News* reported on December 16: "Fearful Shock Occurs Sending Sheet of Flame from Mouth of the Mine," and on December 17: "Work of Recovering Dead Continues at Yolande."

The *Birmingham Age-Herald* wrote on December 19: "Death Harvest Grows Larger Among Miners."

- Hammond Mine, October 1908. While there were few casualties from this explosion at a mine near Gadsden, the damage was extensive. Newspapers at the time reported one miner and one responding

firefighter were killed and others were injured. A headline in the *Charlotte Daily Observer* in North Carolina on October 28 reported: "So terrific was the explosion that almost every plate glass front in Gadsden was broken. Twenty-four miners' houses in the vicinity of the explosion were leveled to the ground and many others are damaged."

- No. 3 mine at Palos, May 1910. An explosion in a mine owned by Palos Coal and Coke Company, forty miles west of Birmingham, killed ninety-one workers. Initially, as many as two hundred were feared dead. The *Nebraska State Journal* in Lincoln, Nebraska, reported on May 6, 1910: "Forty-five white men and between 130 and 140 negroes are entombed in No. 3 coal mine at Palos tonight as the result of a terrific explosion occurring this morning and it is believed all are dead…The flames resulting from the explosion shot into the air from the slope for a distance of 200 feet and the shock was felt for miles."

The *Birmingham News* on May 5 included the headline: "Reports Indicate that No One Will Escape with Life." On May 7, the *Birmingham Age-Herald* reported: "Heroic Rescuers Struggle Bravely to Bring Palos Victims to Surface."

The Mystery of the Moonshine Murders

For more than half a century, law officers in Jefferson County have had one enduring mystery: the disappearance of three men one rainy night from an isolated part of the county. The men—brothers Billy Howard Dye, age nineteen, and Robert Earl Dye, twenty-three, and their cousin Dan Brasher, thirty-eight—headed to a party in Billy's dark green 1947 Ford on March 3, 1956, and were never seen again, dead or alive.

Witnesses told authorities the three had been in an argument at a party at the cabin of Brasher's mother in Sardis, where they had come with Robert Earl's wife, Audrey, and another married couple. After dropping off Audrey and the other couple, the three men went to a party at the home of Billy's girlfriend. There, they encountered a local bootlegger from whom, according to rumor, the cousins had been stealing. Bootleggers were thriving in the rural South at that time.

A man who lived next door to the girlfriend's house, where there was no running water, said some men inside the home came out at about 2:00 a.m. and formed a bucket brigade to take water into the home. Not long after, several men left the house carrying pickaxes and shovels and piled into two cars, one of which was Billy's Ford. The first car came back, the witness said. Billy's was never seen again.

Intriguing Incidents

An employee of a nearby store told authorities a man had come into his store following the cousins' disappearance asking for "anything that might remove blood from a floor." The clerk recommended Red Devil lye, which the man bought.

Had the water and lye been for cleaning evidence?

Were the shovels for digging graves?

Rumors flew. Law officers searched caves, mines and caverns in search of the men's bodies. Tipsters reported the missing men were buried inside the car in the bed of Alabama 79 near Pinson, which was under construction at the time. In the mid-1970s, investigators dug up parts of the highway and bored holes looking for evidence. Using sonar, they saw a mass of metal beneath the highway, but it turned out to be scrap metal.

Then, in 1984, came the biggest break in the case. An ex-convict from Louisiana named T.J. Chamblee confessed to participating in murdering the men, saying he wanted to clear his conscience. Chamblee said he helped dispose of the bodies and the Ford in an abandoned mine near Trafford. But when local authorities went to Louisiana to question Chamblee, they discovered his story held inconsistencies. He was never charged.

To this day, the case remains open. And to this day, stories are told about the night three cousins disappeared without a trace from the face of the earth, about the mysterious case of the Moonshine Murders.

The Great Hurricane of 1893

On October 2, 1893, young Susie Herron boarded the schooner *Alice Graham* in Mobile with the captain and one mate. The two men—Captain Louis Graham and his unnamed assistant—were escorting Susie to nearby Dauphin Island, a barrier island in the Gulf, to open the island's public school. Mother Nature intervened. That day, the most powerful storm in Mobile's history struck the coast, devastating many towns along it.

The hurricane would become known as the Cheniere Caminada Hurricane, named for the town in Louisiana where it did the most damage. Today, the small town is located in Jefferson Parish. Nearby Mobile would not escape the hurricane's wrath.

The *Alice Graham* capsized in the high winds and storm surges and was found overturned after the storm had passed. There were no survivors. The three on board were not the only ones to perish in Alabama during the storm. An unknown but small number of people were killed in the city, and as many as twenty-five were killed in outlying areas.

The *Landmark* newspaper in Statesville, North Carolina, reported that on Farmer's Island, Alabama, only two homes of a total of twenty-three remained. "Relief expeditions to this section found a group of little children clinging to trees, their parents having been swept away," the paper reported.

Intriguing Incidents

In addition, Mobile and coastal areas were cut off from the world. Streetcar, telephone and power lines were downed. Rail service was discontinued for weeks because of damage to the tracks. The *Atlanta Constitution* reported as much as fifty miles of track were under water. Orange and rice crops were devastated. Pecan trees were uprooted.

In the bay, dozens of ships were damaged, cut loose from their mooring and floating aimlessly. Daphne, Montrose, Battles Wharf, Zundeli's and Point Clear all reported extensive damage and wrecked sea vessels.

On October 3, the *Atlanta Constitution* reported:

> *The business thoroughfares of the city were being navigated in boats and parties wading up to their armpits all the afternoon in an effort to save goods. It is conceded by all to be the worst storm that has ever visited Mobile. The south part of the city presents a scene of wreckage as if it had been bombarded. The towers on the courthouse and Christ church are tottering. Dredge No. 5 turned over near the lighthouse and three men were thrown into the angry waves. At great peril the crew of the tug,* Captain Sam, *steamed to the rescue and saved two of the men, the other being lost. An unknown white man lost his footing while wading from Union depot at the foot of Government Street, and was swept under the bridge and drowned.*

Louisiana and Mississippi sustained the brunt of the storm. Much of the southeast portion of Louisiana was flooded. More than half the residents of Cheniere Caminada—779 of 1,500 people—were killed by the high winds or flooding from the storm surge, which was up to sixteen feet. As many as 100 people were killed near Biloxi, Mississippi, and about 30 died on Ship Island off Mississippi's coast.

The Cheniere Caminada Hurricane was the tenth storm of a busy hurricane season. It formed on September 27 in the Caribbean Sea and moved into the Gulf of Mexico as a Category 2 hurricane. By the time it reached the coast of Louisiana, it had strengthened to a Category 4, which has winds of 131 to 155 miles per hour. It hit land October 2, also striking Alabama, Georgia, North Carolina and South Carolina.

When it dissipated, an estimated two thousand people were dead, and damages reached $5 million in 1893 dollars, which would be more than $100 million today.

While this hurricane was the worst in Alabama's recorded history until that time, hurricanes have continued to plague the Gulf coast.

- On September 12, 1979, Hurricane Frederic hit Dauphin Island with 125-mile-per-hour winds and a storm surge of eight to twelve feet, which demolished the bridge from the island to the mainland. As much as 80 percent of buildings along the coastline between

Intriguing Incidents

Fort Morgan and Gulf Shores were demolished. As much as 90 percent of Mobile was without power. Estimated damage was between $6 and $9 billion.
- Hurricane Danny caused extensive flooding on Dauphin Island in 1997.
- On September 15, 2004, Hurricane Ivan flooded a fourth of Dauphin Island with two feet of water. Ivan was one of the most intense hurricanes recorded. It was a Category 5 and as large as the state of Texas at one point, but it struck Gulf Shores in Alabama as a Category 3 with about 120-mile-per-hour winds. Ivan did massive damage along the oceanfront towns of Orange Beach and Gulf Shores, demolishing buildings, flattening protected dunes and washing sand far inland. The oceanfront amusement park with antique rides was left a heap of twisted metal, restaurants and high-rise condos were destroyed and many hotels were closed for months. Ivan spawned 117 tornadoes, including one as far north as Limestone County, Alabama, on the Tennessee line, where a volunteer firefighter was killed by a falling tree while trying to clear debris.
- Hurricane Katrina, which struck on August 29, 2005, is best known for the damage it caused in New Orleans and along the Mississippi coast, but it also caused extensive damage in Alabama. Mobile, Bayou La Batre, Coden and other coastal areas were hit by a storm tide as high as fourteen to eighteen feet. Parts of Mobile were flooded by waters two to six feet deep. Twenty-

two counties in Alabama were declared disaster areas. In Bayou La Batre, shrimp boats were tossed ashore and dozens of homes were destroyed. More than 584,000 people were left without power in Alabama immediately after the storm.

World's Largest Bubble Gum Bubble

In 2009, Chad Fell of Haleyville, a reporter at the *Northwest Alabamian*, rose to the challenge and got his name in *The Guinness Book of World Records*. Fell, forty-one, holds the world record for the largest unassisted bubble blown from chewing gum. The bubble was twenty inches in diameter. Fell held the bubble for five minutes.

In the years Fell prepared for the challenge, his jaws got a workout: he chews two bags of Dubble Bubble each week.

The rules from *Guinness* require that the bubble be made from a maximum of three pieces of gum, but Fell gave some additional tips in the May 2009 issue of *Reader's Digest*:

- Bubbles respond best to warmer temperatures. Bubbles will be larger in a warmer room.
- Chew gum for fifteen minutes before attempting a bubble. Sugar decreases elasticity.
- Chew on the side of your mouth.

Intriguing Incidents

- Chewing must be constant. Don't take a break or you will affect the elasticity.

Bubbles must be properly measured—with calipers—and documented to apply for a world record.

World's Largest Cake Baked in Fort Payne

People may think the biggest thing to come from Fort Payne is the country music group Alabama. But Fort Payne has been recognized for an even sweeter contribution to popular culture. In 1990, *The Guinness Book of World Records* honored the residents of Fort Payne, DeKalb County and Earthgrains Bakery for having created the world's largest cake. During the town's centennial celebration in 1989, bakers put together 12,768 sheet cakes to make a creation that was eighty feet long, thirty-two feet wide and weighed 128,238 pounds. That's almost ten pounds per person: the 1990 census reported the town's population as 12,938 people.

The centennial cake beat the previous record holder by thirty thousand pounds. That cake was created in Austin, Texas, in 1986 for the state's sesquicentennial.

The Fort Payne cake contained 58,314 pounds of sugar and 107 gallons of vanilla flavoring. The pans used to bake the sheet cakes and the foundation that held the entire cake

were made in Fort Payne. Unfortunately, the record didn't last long. In 2005, the residents of Las Vegas celebrated their centennial with an astounding 130,000-pound confection, which included 40,000 pounds of frosting.

To qualify for a Guinness record, the world's largest cake must:

- Contain traditional ingredients in the correct proportions;
- Be prepared in the same manner as a normal-sized cake;
- Be prepared according to appropriate hygiene standards;
- Be edible and safe to eat.
- The final product is built from separate sheet cakes, but it must be iced so no joint can be seen.

THE DEADLY ENIGMA

The temperature on February 19, 1884, was slightly warm for the season in Alabama, hovering just below fifty degrees. The forecast called for rain. The residents of Leeds, a community about fifteen miles east of the bustling city of Birmingham, would have been unaware that danger loomed.

A massive storm was moving from the community now known as Homewood and through the Cahaba Valley. John Poole was home with his wife and six children in

Leeds when a massive twister struck at about 1:20 p.m. The Poole home was demolished by winds of more than two hundred miles per hour. A newspaper account from the *Fort Wayne Daily Gazette* in Indiana stated that Poole's son and daughter were killed and that he, his wife and four other children were seriously injured. However, genealogy records show that a John Columbus Pool of Leeds died on February 19, 1884, along with his seven-year-old daughter, Dora Alice. Lewis Codillus Pool, age fifteen, died within days of the storm. They are buried in Leeds.

Also injured in Leeds that day was Dr. W.F. Wright, a railroad contractor, whose home was swept away by the storm. His children, Annie, Jennie, Thomas, James and Edward, suffered an array of broken limbs, and Wright's mother was thrown one hundred yards from the home and fatally wounded.

When the storm had passed, thirteen people in Leeds were dead, including a cook named Harriet McGrew, a couple named Bass and a Mrs. Kerr, according to news accounts.

This was just one of many storms that would strike Alabama that day. As many as fifty tornadoes hit ten states on February 19 and into February 20, killing an unknown number of people. Because of the lack of records kept on tornadoes at the time, the precise number of deaths cannot be totaled, leading weather experts to dub the incident the Enigma Outbreak. Estimates of the dead—tallied using newspaper accounts and historical documents—range

Intriguing Incidents

from 178 to as many as 2,000. Estimates on the upper end of the scale would make the Enigma Outbreak the most deadly and widespread to ever hit the United States.

In Alabama, the deadliest tornado incident was the Deep South Outbreak on March 21–22, 1932, when 268 people were killed. The most widespread event was the April 3, 1974 Super Outbreak, during which 148 tornadoes hit thirteen states; 86 people were killed in Alabama.

In 1884, weather records were kept by the U.S. Army Signal Corps, which estimated that 182 people were killed across the Southeast during the Enigma Outbreak. But modern researchers believe the deaths of many poor African Americans may not have been reported in newspapers or official documents, which would make the toll rise considerably because their poorly constructed shelters would have been easily destroyed by the strong winds.

Records confirm tornadoes struck over the two-day period in Alabama, Georgia, Illinois, Indiana, Kentucky, Mississippi, North Carolina, South Carolina, Tennessee and Virginia, with most of the damage occurring in Alabama, Georgia, South Carolina and North Carolina.

The tornado that struck Leeds was ranked an F4 by modern meteorologists, again using newspaper accounts. Another F4 would hit Alabama at about 2:30 p.m., touching down near Jacksonville and pushing into Germania, the town now known as Piedmont, where ten people died. Another fourteen died in nearby Goshen when the school was smashed, killing the teacher and injuring students. At

least thirty people died in Alabama before this tornado passed into Georgia.

Georgia was particularly hard hit, with as many as sixty-nine people killed and ten thousand structures demolished by seventeen tornadoes, which still ranks as Georgia's most devastating tornado event.

Part IV

Tombstone Tales

TOMBSTONE TELLS OF MURDER PLOT

At first, the death of Ethel Wright Price seemed a tragic accident. Her husband, H.C. Price, who survived the horrific crash in which his young wife was killed, was the object of sympathy. He was left to raise their young daughter, Winnie Ruth, alone. Before long, the people of Newville would know the truth: H.C. wasn't the victim he appeared to be.

Ethel Price, the daughter of Forrest Wright and Eliza Jane Griffin Wright, died November 9, 1931. The *Abbeville Herald* initially reported: "Mrs. H.C. Price, Jr., 24 of Newville was killed and her husband was seriously injured when a lightless automobile in which they were riding went

over an embankment into a dirt fill near Hartford on the Hartford and Bellwood Road."

According to accident reports at the time, the lights on the couple's car had stopped working, and Mr. Price had stopped and asked a young man named Wallace Bowen to help drive them through a dark area. "While detouring around a washed out section of the road the machine made the fatal plunge. The boy piloting the couple leaped from the machine before it rolled into the gully and was not injured," the *Herald* reported.

Mr. Price was badly bruised and was treated at a Dothan hospital. His story began to unravel when Bowen came forward. The *Wiregrass Farmer* in Headland reported on November 19, 1931: "The second phase of the sensation of following the death of Mrs. H.C. Price, Jr., of Newville was entered into Monday night when Wallace Bowen made what is reputed to be a confession of the manner in which Mrs. Price was killed. This statement charges Price with full responsibility for the alleged murder."

Wallace told authorities that Ethel Price was already dead when the car went over the embankment. The *Wiregrass Farmer* published his statement:

> *Sometime after we had passed Hartford, H.C. Price, Jr., who had been driving the car all the way from Dothan, complained of having indigestion and requested me to drive the car for him. Price at that time*

got into the rear seat of the car and I began driving with Mrs. Ethel Price seated by me. We had gone about three-fourths of a mile after this when H.C. Price, Jr., struck Mrs. Ethel Price with a piece of iron. I knew nothing of his having this piece of iron. Nor did I know anything about his intention to kill his wife. She said "Oh, H.C.!" and then H.C. hit her again on the head. She said nothing more. I stopped the car and got out. H.C. got over the seat by his wife. He speeded up the engine of the car and then jumped out and the car with Mrs. Ethel Price in it went into the big gully. H.C. then turned to me and said, "If you ever say anything about this I'll kill you."

Price and Bowen were each charged with first-degree murder. Price was arrested at the hospital, where he had been since the accident, and both men were taken to Geneva County jail. Authorities learned that Price was the beneficiary of Ethel Price's $3,000 insurance policy, which had a double indemnity clause.

Price, described in *the Abbeville Herald* as "the 25-year-old son of a wealthy planter," was convicted and sentenced to life in prison. Bowen was acquitted. In February 1932, Price was taken to Kilby Prison near Montgomery to begin serving his sentence.

The story may have been lost to history had it not been for Ethel's determined family. They condemned Price for eternity when they erected her tombstone in

Newville Baptist Church Cemetery in Henry County with the inscription:

> *Murdered By Her Husband*
> *H.C. Price, Jr.*
> *So Hard In The Bloom Of Life To*
> *Have Her Life Stolen By The One*
> *Who Promised To Keep And Protect*
> *Through This Life.*
> *Sleep On Precious Child And Mother.*
> *We Hope To Meet And See You Some*
> *Sweet Day.*

GONE BUT NOT FORGOTTEN IN THE BERMUDA TRIANGLE

The disappearance of the USS *Cyclops* is one of maritime history's enduring mysteries and one of its deadliest. The official ruling for the cause for the ship's demise in 1918 while in the Bermuda Triangle is listed as "unknown."

When it disappeared, the *Cyclops* took with it 306 crew members and passengers, making it the largest loss of life in U.S. Naval history outside of combat. Among the crew was Austin Mize of St. Clair County, Alabama, who is listed in ship's records as a seaman. Mize had celebrated

his eighteenth birthday just weeks before the ship's last contact on March 4, 1918. No bodies or wreckage were found, but Mize's family placed a memorial marker in Liberty Presbyterian Cemetery in Odenville, Alabama. The inscription on his headstone reads:

> *Forman Austin Mize*
> *Feb. 13, 1900*
> *Lost On U.S.S. Cyclops*
> *March 1918*
> *Gone but not forgotten*
> *Son*

The *Cyclops* was built in Philadelphia and launched in 1910 as a collier. On May 1, 1917, it was commissioned the USS *Cyclops* and carried coal and other cargo for the U.S. Navy as America entered World War I.

On February 16, 1918, the USS *Cyclops* left from Rio de Janeiro, Brazil. It then entered Bahia and, after two days in port, left for Baltimore, Maryland, carrying eleven thousand tons of manganese ore to be used to make munitions for the war effort. Some say this load was more than the ship's capacity. In addition, the ship's lieutenant commander, George W. Worley, had reported before leaving Bahia that a cylinder had cracked on the starboard engine. A board approved the ship for travel and recommended Worley return to Baltimore immediately.

The ship reportedly made an unscheduled stop in Barbados and then continued toward the United States. The last contact from the USS *Cyclops* was heard on March 4. A severe storm was reported on March 10, but it is uncertain if that contributed to the disappearance. The date of death assigned for the 21 officers and 285 enlisted men on board—some of whom were assigned to other ships and were on this voyage as passengers—was June 14, 1918.

The conclusion after a naval investigation was: "Many theories have been advanced, but none that satisfactorily accounts for her disappearance."

THE MOURNING ROSE

The Reverend Arthur M. Small arrived in Selma in November 1860 and began his service as pastor of the First Presbyterian Church on Broad Street in April 1861. The young pastor had become a beloved addition to the community by the outbreak of the Civil War. He joined the two thousand or so young men in a local militia prepared to defend their city.

On April 2, 1865, as Union troops advanced, Small decided to go ahead with his sermon before the enemy could arrive. Following the sermon, the thirty-two-year-old pastor joined the townspeople and Confederate soldiers against the Union army in what would become

known as the Battle of Selma. Much of the lovely city was looted and burned.

Small was killed during the conflict. Legend states that Small's body was returned to the church manse and laid upon its steps. The huge Lady Banks rosebush growing nearby shed its petals in mourning. Soon, Small's body was covered in its yellow petals. The Lady Banks rose, commonly grown in China, is unusual in that it has few thorns. It flourishes in Selma's climate.

Small was buried in Selma's historic Live Oak Cemetery beneath a large monument that is inscribed: "In Memory of Rev. Arthur M. Small, Pastor of the Presbyterian Church, Selma, Ala., Born in Charleston, S.C., Oct. 20, 1832, Fell at the Battle of Selma, April 2, 1865."

According to the Selma Presbyterian Church website, the Lady Banks rosebush was saved when the church manse was demolished in 1852 and was replanted when the church's educational building was erected at the site. It remains there today, a reminder of a young man who gave his life defending his town.

Coon Dog Graveyard Draws Storytellers

An old-timer likes to tell of the time during a funeral when the pallbearers got distracted and chaos ensued. "A

rabbit ran through and they dropped that casket and took off running," L.O. Bishop said. "It took us two days to get them rounded up."

Bishop laughed when caught in a tall tale, which he began by saying that local dogs that are too old to hunt often haul caskets for funerals in the Key Underwood Coon Dog Memorial Graveyard.

The cemetery, the only one of its kind in the world, seems to inspire storytellers. Each Labor Day, the cemetery in Colbert County is the site of a Labor Day celebration that includes music, dancing, food and a "liar's contest."

Located in a remote, wooded area twenty miles southwest of Tuscumbia, the cemetery is maintained by the Tennessee Valley Coon Hunters Association. Only canines certified as

coon-hunting dogs may be buried there. A spokeswoman for the Colbert County Tourism and Convention Bureau said at least one burial is documented in which pallbearers—of the human variety—and a casket were used.

On the web site www.coondogcemetery.com, William W. Ramsey posted a eulogy he had written for his dog Ole Red, which was used in that burial. His son, Bradley Ramsey, added this introduction about the funeral service: "A group of solemn men, dressed in black mourning coats and hip boots, wearing carbide lamps on their heads stood beside a mound of soil and a freshly dug hole. A hunting horn sounded and the bay of hounds filled the air. Four similarly dressed men walked slowly toward the gathered crowd, a small wooden box carried between them."

The last lines of Ramsey's eulogy memorialize the relationship between hunter and dog:

> *He knows in coon dog heaven he can hunt again*
> *when the sun goes down and the tree frogs holler.*
> *May the bones of Ole Red rest in peace,*
> *through the mercy of God*
> *and may the coon hunters light perpetually shine upon him.*

"Key" Attraction

Many people think they are the first to uncover a rare gem when they travel to this remote location to see the Key Underwood Coon Dog Memorial Cemetery, said Susann

Hamlin. But as executive director of the Colbert County Tourism and Convention Bureau, Hamlin often bursts that bubble by telling people it is one of the most popular tourist attractions in northwestern Alabama.

"We have calls all the time," she said. The cemetery has been featured in newspapers and magazines such as *Southern Living*, *Field & Stream* and *Bassmaster*, as well as on television shows such as Charles Kuralt's *On the Road* and Turner South's *Liars and Legends* and *Blue Ribbon Cemeteries*. "It's an interesting little place," she said. "Reading the headstones is real interesting, too."

People walk into the Colbert County Tourism and Convention Bureau daily asking for directions, she said. The cemetery has become so popular that the bureau now sells the world's only Official Coon Dog Memorial Cemetery T-shirt and camouflage baseball caps. "This is the only place you can get them," she said. They feature images of the grave of Troop, the first dog buried at the site. Shirts and caps are twelve dollars each, but discounts are available for large quantities. Proceeds help maintain the cemetery.

The Tourism and Convention Bureau on U.S. 72 in Tuscumbia is open weekdays and opens Saturdays from 9:00 a.m. to 4:00 p.m. in the summer.

Hamlin said the attraction has become so popular that the tourism center has developed a color travel brochure. "We'll place it at welcome centers across the state," she said.

Since 1937

The cemetery is named for Key Underwood, who buried his dog, Troop, in the woods where they hunted together in 1937. In a 1985 interview, Underwood said he never intended the site to become a cemetery. But as other hunters needed a place to honor their loyal hunting dogs, the secluded site became a popular burial ground.

"The most unique thing about the cemetery is that Key Underwood buried his dog Troop there in 1937 and it developed from that," said Bishop, who owns Bishops' Barbecue, which packages barbecue for restaurants and stores. "If they'd had a meeting to develop a coon dog cemetery, it probably never would have happened."

About 185 dogs have been buried at the site, with names such as Straight Talkin' Tex, Fanney, Preacher, Ranger, Hickory, Kate, Rusty, Queen, Loud, Doctor Doom, Beanblossum Bommer, Hardtime Wrangler and High Pocket.

When Track died in 1989, his owner gave him this memorial: "He wasn't the best but he was the best I ever had."

Bragg's stone says: "The best east of the Mississippi River."

To ensure purity of the breed, any dog to be laid to rest must have these qualifications:

- Owners must claim their pets are authentic coon dogs.
- A witness must declare the deceased is a coon dog.
- A member of the local coon hunters' organization must be allowed to view the coonhound and declare it as such.

"We have people call and ask us if they can bury their pets there and we say, 'No, this is not a pet cemetery,'" Hamlin said.

But the most unusual request came from a tour operator in Kentucky who wanted to have a mystery tour and end it with a fancy dinner at the cemetery. "He wanted to package it as an elegant dinner for a group doing a mystery tour," she said. "He always wore a tuxedo, so he wanted to have waiters in tuxedos serving steak and salad and potatoes." The event was a success, Hamlin said.

Groups of twenty or more who just want simpler fare can order a tour with watermelon and lemonade by calling the Tourism and Convention Center at (800) 344-0783. No admission is charged for viewing the cemetery. "We also have a package for river barge excursions," she said.

Bishop said as many as four hundred people may visit the cemetery during the Labor Day celebration. On other days, visitors come whenever the urge strikes. "I have never been to the coon dog cemetery when I didn't see people come in," Hamlin said.

Bishop, who once recorded a tape of dogs treeing a raccoon so he could play it for tours at the site, said some might find the cemetery a mere curiosity; he sees it as a resting place for the hunter's best friend. "It doesn't mean a lot to everybody, but it does to some of us," he said.

Preaching from the Grave

The Reverend Joshua Boucher gave some passionate sermons as the second circuit preacher in Limestone County, Alabama. Before he died in 1845, he reportedly found a way to continue his life's work beyond his death.

Boucher (pronounced Butcher) is said to be buried standing up in the old Athens City Cemetery on East Washington Street. Some say Boucher thought his arthritis might prevent him from rising from his grave when Gabriel blows his horn. Others say he wanted to keep ministering to a congregation—even if the congregation was dead. Boucher was a preacher for the Tennessee Methodist Conference who rode a circuit of six churches in Limestone County. He was licensed in about 1811. He was born in western Virginia on October 23, 1782, and his father was killed by Indians within Joshua's first year of life in Washington County, Virginia.

Boucher moved to Alabama in about 1808 and died in Athens on August 23, 1845.

According to a local historian, the late Faye Axford, historical records show that Boucher was buried vertically rather than horizontally, but the records do not give a reason for this unusual request.

LEE GRIFFIN BURIED IN TWO ALABAMA CEMETERIES

Lee Griffin was buried in two places more than half a century apart.

Griffin, son of Dempsey Griffin and Eliza Jane Griffin, was a young man working at a cotton gin near Newville when his arm was caught in the machinery and was amputated. The arm is buried in Newville Baptist Church Cemetery in Henry County. Its burial site is marked with a small concrete ball inscribed with the date September 13, 1906. Griffin would have been about twenty-five years old at the time.

Griffin went on to have a prosperous life. He owned land in Henry County, Houston County, Alabama, and Seminole County, Georgia, where he operated wagon dealerships and livery stables and was a mule and horse trader. He also owned cotton gins in Newville and Headland, as well as a stable and mercantile in Headland.

When Griffin died in 1958, the remainder of his body was interred in the Methodist Cemetery in Headland, where he lived at the time.

The burial site of his arm would have been long forgotten if not for lore handed down through the family. Roberta Childs, Griffin's niece, gathered stories from Newville Baptist Church Cemetery for a book, which lists the location of the grave for Lee Griffin's arm as being near the west side entrance of the church.

THE TODDS: A HOUSE DIVIDED BY WAR

The Todd family was one of many divided by the Civil War. Mary Todd married Abraham Lincoln, while many of her half siblings supported the Confederacy. Two of

Mary Todd's younger half sisters, Martha Todd White and Elodie Breck Todd Dawson, lived in Selma.

Mary Todd was raised in Kentucky in a slave-owning family but grew to oppose slavery. She was considered by many southerners as a traitor. Two of her stepbrothers and a brother-in-law were killed fighting for the Confederacy. When her brother-in-law, Confederate General Ben Hardin Helm, was killed at the Battle of Chickamauga, Mary Todd reportedly took in his widow, her half sister Emilie Todd Helm. Martha Todd White accompanied Emilie through Union lines for a month-long visit to the White House in December 1863.

Martha did not visit the President and Mary Todd during this trip and soon returned to Alabama. President Lincoln issued a pass for her to return home, causing a furor that Martha was given special privileges. Some people thought Martha used the pass to smuggle medical supplies and other items back to the South for the war effort.

Martha had married Clement White, and her younger sister, Elodie Todd, would marry Captain Nathaniel "Nat" Henry Rhodes Dawson of the Magnolia Cadets during the war.

The sisters attended the inauguration of Jefferson Davis as president of the Confederacy in Montgomery in 1861.

Later in 1861, Martha and Elodie sewed a flag for the cadets, a group that later became Company C of the Fourth Alabama Infantry. The flag became property of the Alabama Department of Archives and History after it

was donated in 1903 by Dawson's son, Henry, of Minter. It remains there today.

Elodie and Nat were engaged when he left for war. He carried into battle with him a locket containing a snippet of young Elodie's hair. Soon, the two married. Elodie and Nat Dawson were members of St. Paul's Episcopal Church, which was burned by the Union army. Nat helped oversee the construction of a new church, which still stands. Elodie presented the church with a communion ewer in 1869, and it is still in use. She also was instrumental in getting a Confederate memorial raised in Live Oak Cemetery.

The Dawsons had two children together, Salma and Percy.

Elodie Todd Dawson died in 1877 at the age of thirty-seven. Her grief-stricken husband ordered a large ornate likeness of his wife leaning against a cross and holding a garland of flowers. The monument was carved in Italy, and when it first arrived, Nat sent it back, stating that the statue's hair was not as beautiful as his wife's. When the statue was sent back from Italy, it included intricately carved ringlets. It stands today in Live Oak Cemetery at the grave site of Elodie and Nat Dawson.

After his wife's death, Captain Dawson became speaker of the Alabama House of Representatives and later was the U.S. commissioner of education.

Martha died in 1868 at the age of thirty-five. She and her husband had no children. She is buried in Live Oak Cemetery.

Unique Brick Headstone Honors Mason

William Wilkerson Lovell, who once owned Lovell Construction in Athens, spent his entire working life as a brick mason. When he died on March 12, 2009, at the age of eighty-seven, his grandsons decided to honor his memory in the best way they knew. Bert Wilson, Stuart Wilson and Jordan Lovell, who were taught the craft of masonry by their grandfather, created a brick headstone for his grave in Roselawn Cemetery off U.S. Highway 31.

"We felt like it would mean more to him than a piece of granite," Bert Wilson said. The headstone faces the highway and contains granite blocks with his name, birth and death dates etched on them, as well as a block with the name of his wife, Pauline Fielding Lovell, who survived him.

A granite stone in the center of the brick monument is inscribed with Billy Lovell's favorite Bible verse, Colossians

3:23: "Whatever your hand finds to do, do it heartily as to the Lord and not to men."

"I can't tell you how many times he told me that," Bert said.

Billy Lovell also was a U.S. Navy veteran, farmer, a member of the Limestone Cattlemen's Association, a member of Athens-Limestone Home Builders Association and a board member for fifteen years of Athens Bible School.

But those strolling through Roselawn Cemetery will know at first glance his true calling in life.

LITTLE GODFREY CORDIAL

A small monument marking the grave of a baby in Old Center United Methodist Church Cemetery in Newville is a sad reminder of infant mortality rates in the 1880s.

That's where this story would end if not for the unusual name on the marker and the legend behind it. The headstone is inscribed:

> *Our Infant*
> *Godford Corcial*
> *Dau. of*
> *J.E. and S.J. Brannon*
> *1881*

According to local lore, the grieving mother of the infant asked a man who was traveling to a nearby town to order a

headstone. She wrote on a slip of paper what the inscription should say: "Our Infant, Daughter of J.E. and S.J. Brannon."

As the man was leaving, he asked Mrs. Brannon if she needed anything else. She replied: "Godfrey's Cordial," and the man wrote that on the same slip of paper as the inscription. In the 1800s, Godfrey's Cordial was an elixir used for colicky infants. It contained sassafras, opium, alcohol, caraway seed and treacle. It was named for Thomas Godfrey of England, who developed it before 1825. Called "mother's helper," it was one of several liquids, including Bateman's Drops, sold in stores to calm infants. Infants would fall immediately asleep after taking the liquid. Unfortunately, many of them also died.

As mothers would learn in coming years, the mixture was a strong narcotic. By the 1890s, newspapers would publish advertisements for medications such as Castoria, which claimed to have all-natural ingredients, and called Godfrey's Cordial, Bateman's Drops and other opiate elixirs "stupefying narcotics."

When the man ordered the headstone for the Brannon infant, whose cause of death and real name are lost to time, he handed the carver the slip of paper. Reportedly, the carver thought it included the infant's name. How it got misspelled remains a mystery. Sloppy handwriting, perhaps?

The headstone remains today because the family could not afford to have a second stone cut. Old Center United Methodist Church Cemetery is on Henry County Road 89.

First Black Congressman from Alabama

Benjamin Sterling Turner was born a slave March 17, 1825, near Weldon, North Carolina. Though he received no early education, he managed to study on his own. He moved to Alabama in 1830. Turner's owner, Major W.H. Gee, owned the St. James Hotel in Selma and trusted Turner to operate it while Gee was away during the Civil War.

Turner is said to have married, but a white man purchased the woman as his mistress. After Turner became a free man with the Emancipation Proclamation, he also owned a livery stable in town.

Soon, he entered the political realm. He was elected as tax collector of Dallas County in 1867 and sat on Selma's city council in 1869. When he was elected as a Republican to the U.S. House of Representatives, he became Alabama's first black congressman. He served from March 4, 1871, to March 3, 1873. He lost his bid for reelection. He died in Selma in 1894.

In 1985, a group of Selma residents, who had learned a grave in Live Oak Cemetery belonged to Turner's wife, determined the grave beside hers to be Turner's final resting place. It had no headstone, and the group wanted to honor this prominent man. They erected a marker inscribed:

Benjamin S. Turner
March 17, 1825
March 22, 1894
Placed By A Bi-Racial Group
March 31, 1985

When Lightning Strikes, and Strikes, and Strikes

William Cosper of Childersburg wasn't what you'd call lucky in life—he was struck by lightning twice. The second time, he didn't survive. But death could not stop his streak of bad luck. Lightning continued to plague Bill, even after death.

Bill's bad luck began one day when he and his wife, Martha, decided to spin wool inside their home rather than in the yard because a storm was brewing. Suddenly, lightning struck inside their home, setting fire to the pile of spinning wool. No one was injured.

A few weeks later, Bill was watching a storm from the porch when he was struck by a bolt of lightning and killed. His grave is located in Childersburg City Cemetery.

Strange weather phenomena were still attracted to Bill, even in death. His tombstone was struck by lightning not long after his burial. All that was left was a pile of rubble. His family bought a new monument.

Lightning struck again, destroying the marble monument. Finally, Bill's family gave up and placed a stack of bricks and pieces of the ruined marble monument to mark his final resting place.

This story is told as true, although some might find it difficult to believe. The producers of a popular television show believed enough that they once featured the story— on *Ripley's Believe It or Not*.

THE MYSTERY GRAVES OF NORTH ALABAMA

What happens when a highway crew encounters long-buried bodies while digging? The dead go to the highest bidder. At least, they did in one unusual case in northern Alabama.

In 1968, while completing Interstate 65 from Birmingham to Nashville, crews encountered several bodies buried in southern Limestone County near the edge of the Tennessee River. Initially, 12 bodies were unearthed, but still more were found, until the final count was 194 bodies. No grave markers remained, and with one exception, the dead had been buried in wooden coffins, only a few of which remained.

Using scrapers, the crews could see dark spots in the earth that indicated where bodies were buried. Local historians believed the bodies must once have

been residents of a long-forgotten town near the river called Cottonport, which was settled in 1818, the year Limestone County was officially formed.

Cottonport, which had a landing along Limestone Creek for steamboats that entered from the Tennessee River, was a thriving community with a town square, homes, warehouses for cotton and other goods to be transported and even a racetrack. It was the watery area's plentiful mosquitoes that led to the town's demise. A malaria epidemic in the 1850s chased residents farther inland, and the town soon ceased to exist.

The 194 mystery graves were likely those buried in a town cemetery during the community's more than thirty years of existence.

The Alabama Department of Transportation, which now owned the land in which the bodies were found, had to decide what to do with them. No one knew the identities of the dead, and in any case, their descendants were likely scattered. So highway officials did what highway officials do: they put the project up for bids. Funeral homes across the state were asked if they would like the job of reinterring the bodies.

It was a funeral home more than fifty miles away, in the small community of New Hope in neighboring Madison County, that won the bid. The owner of the funeral home purchased a small parcel of land adjoining Hayden Cemetery for the reinterment. The state reportedly paid $45,000 to have the bodies moved.

At Hayden Cemetery, the bodies are marked with inset granite stones, each inscribed with a number and set randomly in three rows at the edge of the cemetery. A sign among the markers reads: "194 Unknown Graves."

Hayden Cemetery has been in use since 1858 on land later donated to the community by Tranquilla J. Hayden. A state historical marker at the site refers to the mystery graves, mistakenly stating the bodies were from Collier Cemetery in Limestone County. Two Collier family cemeteries still exist in Limestone County, and they lie in the western portion of the county rather than along the interstate route.

One of the enduring mysteries of the unknown graves is a body that became known locally as the Man in the Cast-Iron Casket. Highway crews unearthed a Springfield 92 model casket manufactured in the early 1800s. They could see a window in the upper half of the cast-iron casing, but it was darkened with age. Once the glass was cleaned, workers could see what appeared to be the remnants of a man's clothing on a skeleton, with a diamond stickpin still in the lapel.

At some point, rumors about the man began circulating. Someone said the stickpin was stolen, and the Madison County sheriff exhumed the body to check. Another said the casket and its contents were whisked away by the FBI.

What happened to the Man in the Cast-Iron Casket? His whereabouts are just another part of the mystery of the 194 unknown graves.

Images Frozen in Time

In a tiny church cemetery off a dirt road in southwestern Alabama, concrete visages stare back at those who happen to stumble across it. A series of twisting roads—some paved, others not—takes travelers deep into the woods of Clarke County to Mount Nebo Baptist Church.

Four graves in Mount Nebo Cemetery, which was listed on the National Register of Historic Places in 2000, are

marked with what some call "death mask" headstones crafted by a man about whom little is known, except that he was an inventor and possibly a creative genius. The stones were created by Isaac Nettles Sr. Local historians determined that the masks were made while the subjects were alive. Nettles would have pressed his subjects' faces, usually those of family members, into wet sand and then poured a homemade concrete mixture into the impressions.

Some of these unique stones have been mutilated by time, weather and vandals, but a few are in pristine condition. No one knows how many of the unique markers once were located here. Isaac Nettles Sr. was born about 1885 in a

nearby community known as Nettles Quarters. He likely died in the late 1950s or early 1960s. The exact dates are not known because the man who created such unusual grave markers is buried in an unmarked grave somewhere in the cemetery, according to Kerry Reid with the Clarke County museum.

Of the four existing face markers, only two are undamaged. One marker features three faces and is marked with the word "mother." Reid said it marks the grave of Isaac's wife, Korea Nettles, who died in 1933, and bears the faces of the couple's three daughters—Pauline, Marie and Clara.

The marker Isaac made for his mother Selena, also from 1933, once was the most unusual of his creations, but, sadly, it has been destroyed. The bust is now missing its head, but remains can be found of the troughs that flanked the head, inlaid with tufts of hair.

Another nearby grave is marked "Manul Burell. Died 1946. He is at rest." A shirt collar and buttons were drawn into the concrete beneath the mask. Burell's marker was damaged—some say the victim of vandals, others say corrosion—and has since been painted white, which Reid said is not an unusual custom in the area. The stones have been designated historic sites by the National Park Service, which states the markers "represent a unique burial tradition." The "frozen face" motif has been identified by folklorists as characteristic of African-derived symbolism in African American art.

Historians believe Nettles attended the famed Tuskegee Institute and studied under Booker T. Washington but did not graduate. He was an inventor who developed odd-looking machines in a shop on his property. Will White, who was one hundred years old when interviewed in September 2007, said he witnessed a machine Nettles had invented that worked using weights. Though he did not know the purpose of the machine, White said Nettles refused to sell it because he was not offered enough money. Reid said that according to local folklore, Nettles had invented a perpetual motion machine that drew the interest of the Ford Motor Company.

In 2006, a Rockford resident found a concrete bust of a black man buried on his property and donated it to Clarke County Museum, according to the *Clarke County Democrat*. Reid said she believes the bust could have been made by Nettles.

The museum hopes to obtain funding to search for other stones made by Nettles and to preserve the ones at Mount Nebo. Those who attend Mount Nebo Baptist Church are aware of the importance of the unique folk art tombstones in the adjoining cemetery and try to protect them from outsiders.

Part V

Curious Creatures and Odd Occurrences

Matilda's Best Trick: Living Longest

As a soft snow fell in Bessemer, Alabama, on February 11, 2006, a family gathered at the deathbed of a loved one. Before the day was out, Matilda's failing heart stopped. Her family mourned.

Matilda was an unassuming-looking beige Red Pyle bantam hen, an unlikely candidate to cause such grief among her human owners, much less a candidate for fame. She was honored upon her death with a broken perch ceremony at the Birmingham Hilton Perimeter Park Hotel, similar to the way magicians are honored upon death with a broken wand ceremony.

But Matilda, as Keith and Donna Barton of Bessemer will tell you, was special. She was a star.

Keith and Donna chose Matilda from a pen at a poultry show at Alabama State Fairgrounds in Fairfield in 1990 and

purchased her for ten dollars, wanting a hen to participate in tricks when the couple performed magic acts as Mort the Mystifying and Donna. Matilda filled the bill.

She would soon surpass simple fame as the star of a local magic act, however. Matilda would achieve fame on the world stage, attaining the title World's Oldest Living Chicken, certified by *The Guinness Book of World Records* in 2004, when Matilda was fourteen. She lived to be sixteen years old. The average lifespan of a chicken is seven or eight years.

It was when Matilda turned eleven that the Bartons first contacted Guinness Book. It took three years of back-and-forth paperwork to Guinness's London office before the title was certified.

Several veterinary and avian specialists have said they believe Matilda's longevity is due to the fact that she never laid eggs. Donna also said she believes Matilda's sheltered life away from predators and her love of performing added years to her life.

From her magic debut at Bessemer Public Library in 1991, Matilda loved the spotlight, Donna said. In the act, Mort the Mystifying would close the lid of a pan on an egg yolk, and then, when he removed the lid, Matilda would appear.

Matilda must have been in her element in September 2004 when she and the Bartons were guests on *The Tonight Show with* Jay Leno. In addition to poking subtle fun at Donna's deep southern accent, Leno fed breadcrumbs to Matilda on his desk and asked to see one of Matilda's

tricks, an impersonation of the NBC peacock. Soon after the appearance, Matilda retired from performing due to health problems.

In addition to her world record, Matilda was inducted in the Alabama Animal Hall of Fame and received the Olivia Bearden Award from the Greater Birmingham Humane Society for service to man and animal.

While Matilda will never be replaced in the hearts of Keith and Donna Barton, she has been replaced in the magic act. The Bartons purchased a Nankin bantam hen named Scarlett at the fairgrounds in Chilton County.

"Scarlett walked up to me," Donna says, remembering the day she chose the hen that now works with Mort the Mystifying and Donna. While Nankins are known to be prolific laying hens, Scarlett, like Matilda, does not lay eggs. Donna hopes this means that Scarlett also will have a long life.

When Fish Fell on Chilatchee

It had been a clear day in the spring of 1956 in Chilatchee, a community in Wilcox County, when a cloud suddenly formed overhead. A couple named Phillips would later report that they were watching the cloud when it suddenly released the most unusual rain to ever fall in the area: a rain of live catfish, bass and bream. The fish dropped for fifteen minutes onto a two-hundred-square-

Curious Creatures and Odd Occurrences

foot area of farmland before the cloud just as suddenly, free of its contents, turned white and disappeared. The Phillipses, not wanting to waste their strange windfall, gathered the fish in a washtub.

This story is oft repeated on the Internet and in books of local lore. This is not the only example of fish rains in Alabama. Smaller incidences have been reported through the years.

Weather expert Bill Murray of Birmingham said an October 23, 1947 fish fall in Marksville, Louisiana, was documented in the *American Meteorological Society Journal*. He said dozens of fish fell over an area of about eight blocks in the middle of town that day. In some parts of the world, other creatures have fallen from the sky, including frogs and birds.

Some of the most unusual incidents reported include jellyfish falling from the sky in Bath, England, in 1894; worms in Jennings, Louisiana, on July 11, 2007; and spiders in Salta Province, Argentina, on April 6, 2007. Murray said fish falls have a meteorological explanation: a waterspout or some kind of concentrated whirlwind in a river or lake in the area shoots the fish into the clouds. They can remain in the clouds for miles before dropping back to earth, he said.

While the explanation removes some of the mystery from the phenomenon, it certainly wouldn't prevent the shock of having a fish drop onto your head on an otherwise ordinary day.

THE WOLF WOMAN OF MOBILE

She was mysterious. She was beautiful. She was…hairy. In the spring of 1971, a creature dubbed the Wolf Woman of Mobile made her appearance to people along Davis Avenue and in the community of Plateau. Witnesses described the

creature as having the lower body of a wolf and the head of a woman. She was seen at night, stalking residents but never harming anyone.

She so frightened the citizenry that people began calling the local newspaper, the *Mobile Press Register*, to report the sightings. On April 8, 1971, the newspaper reported the phenomenon, complete with a drawing of the creature conceived by a newspaper illustrator: "Listening to as many as 50 phone calls the *Press Register* has received, day and night, in approximately a week, you wonder if perhaps there isn't something out there."

Witnesses described the creature as "pretty and hairy," and "the top half was a woman and the bottom was a wolf."

An unnamed teenager is quoted as saying: "My daddy saw it down in a marsh and it chased him home. Now, my mommy keeps all the doors and windows locked."

One witness heard that the creature had escaped from a circus sideshow.

The reporter said the fear of witnesses seemed real, although the initial reports would have begun on April Fool's Day. The police were getting calls, too, and although officers would not make an official comment, they did investigate to determine what, exactly, Mobile's citizens were seeing. The outcome of the investigation was not reported.

Sightings of half-wolf, half-human creatures have been reported throughout history, with the werewolf being the most common incarnation. The legends of

anthropomorphic creatures stem from American Indian folklore and capture the imagination.

Within days, sightings of the Wolf Woman stopped, and the half-wolf, half-woman was never seen again.

One paranormal investigator thinks the creature could have been a feral woman, but if so, where did she go? Is she still roaming the darkened streets of Mobile?

Snake Handlers Are True Believers

The year 1955 was a busy one for the faithful who believe in the practice of "taking up serpents." That was the year a man known as the group's founder was killed by a snake bite, three brothers began a riot by bringing a snake into a small Alabama church and a pastor from Kentucky was killed in Fort Payne, Alabama, by a snake bite.

In the early twentieth century, snake-handling religions, which many describe as cults, became active in the Appalachian Mountain regions of Alabama, North Carolina, Kentucky, Tennessee and Virginia. Many residents in these communities think any publicity of snake handlers gives a negative stereotype about mountain people. The practice of snake handling during religious ceremonies was begun in 1909 by George Went Hensley of Grasshopper, Tennessee, a Church of God pastor who preached that the Bible should be taken literally, including the verse Mark

16:17–18: "And these signs shall follow them that believe; In my name shall they cast out devils; they shall speak with new tongues; they shall take up serpents; and if they drink any deadly thing, it shall not hurt them; they shall lay hands on the sick, and they shall recover."

When the Church of God later banned the practice, Hensley formed his own church and continued handling snakes. He and his followers believed that if they were bitten and died, it was God's will. Any bites remained untreated, so if the bitten person survived, that, too, was God's will.

Snake handlers began to grow in number, and in 1912, a man named James Miller formed a church on Sand Mountain, Alabama, reportedly independently of Hensley's church. By the 1940s, following a number of snakebite deaths, states began to outlaw the practice of serpent handling. Only West Virginia allows the practice legally.

While numbers are difficult to track, experts believe as many as one hundred people have died handling snakes.

In a May 1953 Associated Press article about outlawing snake handling in Alabama, a reporter wrote that the state legislature had made the act of snake handling a felony because it "endangered the life or health of another."

The article detailed an account of a bite sustained by Lotti Franklin at the Holiness Church at Straight Creek near Arab, Alabama. She refused medical attention, and the stricken site swelled dangerously. She was quoted as saying, "I didn't have faith enough and that is why my arm swelled."

1955

In July 1955, newspapers reported a strange disturbance at a small rural church in Lauderdale County, Alabama. Under a story headlined "Three Rattlesnake-Handling Brothers Panic Church, Tell of 'Miracle Dream,'" the *St. Petersburg Times* in Florida reported: "Three burly brothers who threw a rural congregation into panic by taking a writhing rattlesnake to church said Saturday they plan more religious rites with deadly serpents."

Mansell Covington, thirty-seven, had entered Bumpas Creek Church with the snake entwined around his body. Mansell and his brothers Allen and George, all of Tennessee, were later arrested and charged with disturbing public worship.

At first, they did not post bail because they predicted "the Lord will make the jailhouse doors swing open."

Mansell told authorities the idea of handling serpents came to him in a dream. "'I dreamed I was handling a little snake first,' he recalled. 'A little cottonmouth. Then I dreamed I was handling a big rattlesnake,'" Mansell was quoted in the *St. Petersburg Times*.

The next day, he went out to find a rattlesnake to handle and came upon a cottonmouth. When it bit him, Mansell said, "I just looked up to the Lord and said, 'Lord, it's all up to you.'"

Later that same month, snake-handling church founder Hensley was bitten by a diamondback rattlesnake and killed

during a service in Florida. He was seventy. While it may seem that would shake his followers' faith, it seemed to have an opposite impact: his widow, Sally, vowed to continue her husband's mission, and the church continued.

About a month later, another snakc-handling preacher, Lee Valentine of Pineville, Kentucky, died ten hours after being bitten by a rattlesnake during a service in Fort Payne, Alabama. He was fifty-two. "An overflow crowd" came to a memorial for Valentine, according to an article on August 17, 1955, from the Associated Press. At the service, those in attendance handled two copperheads, sang, played guitar and eulogized Valentine.

Also during the service, preacher Oscar Sutton announced that the snake that had bitten Valentine would be handled by his Pentecostal congregation at a "big meeting" in Virginia.

Murder by Snake

Snake handling reached the height of its publicity in 1991, when a snake-handling pastor from Scottsboro, Alabama, was accused of trying to murder his wife with snakes.

Glenn Summerford, a preacher who had risen to a high level in the church, was accused by his wife, Darlene, who said he forced her hand into a box full of snakes. After she was bitten repeatedly, Summerford left her for dead. But Darlene survived to testify against him. Summerford was convicted and sentenced to ninety-nine years in jail.

Snake handling is still practiced today in tiny churches tucked away in mountain communities, but experts believe fewer than two thousand believers remain across the United States.

UFOs over Alabama

February 11, 1989, was a typical Friday at the Fyffe Police Department—until the phone calls began. That day and into Saturday, more than fifty people phoned in

reports that Chief Charles "Junior" Garmany didn't hear every day, and in fact never before or since: sightings of unidentified flying objects.

In the town of about one thousand souls in the Sand Mountain region, officers could only wonder if residents were suffering mass hysteria or if some sort of new missile was being tested at Redstone Arsenal in Huntsville. Garmany and Assistant Chief Fred Works decided to see for themselves. They drove out County Road 43, where some of the sightings had occurred. Garmany and Works soon spotted an unusual object and came to the same conclusion as residents—it wasn't anything identifiable on this earth.

"The object came on over and got straight overhead," Works said in a newspaper account. "It…appeared to be a wide triangular shape. We kept waiting to hear the sound. We kept looking at each other and saying, 'Where's the sound?' We never heard anything."

Fyffe resident Donna Saylor had watched the lights for more than an hour before calling police with her description. It was crescent-shaped and lined with green lights, and Saylor reported that it looked like a banana, a description she was later teased about and wished she had not used. A T-shirt later created by a local resident saying "I survived the Sand Mountain UFO" featured a giant banana in the sky.

When the news was reported locally, more than one hundred news organizations from around the world converged on Fyffe.

The phenomenon could not be explained by the National Weather Service or NASA's office in Huntsville and remains unexplained. The city now celebrates its history with an annual event called Fyffe UFO (Unforgettable Family Outing) Days, a hot air balloon festival.

Fyffe and Garmany would be in the news again a few years later when a series of cow mutilations occurred in several north Alabama towns. In November 1992, police in Fyffe and neighboring towns joined forces to investigate the mutilations, which were first reported October 20, 1992, in Marshall and DeKalb Counties.

Dozens of cows were found dead with various internal and external organs missing, seemingly removed by precise surgical cutting. In many cases, the wounds appeared to have been cauterized. Though many animals were found in soft pastureland or mud, no footprints or animal tracks were found near their carcasses. The mystery surrounding the apparent attacks led to rumors that they were experiments conducted by aliens.

The first documented incident of cattle mutilation in Alabama that year was reported by Albertville cattle farmer John Strawn. The cow's milk sac had been removed, but there was no blood on the animal or the ground. Other farmers in the Albertville area soon started reporting mutilations over the next two months. In many cases, the rectum had been cored out neatly, with no evidence of blood or body fluid present. Reproductive organs had been removed with neat, bloodless incisions. In early January

Curious Creatures and Odd Occurrences

1993, Tommy Cole, Albertville Police Department's chief of detectives, reported that a Black Angus steer on his ranch was found mutilated.

Cattle farmers reported seeing or hearing helicopters around the time mutilations were discovered. No one was ever charged in the incidents, which finally stopped after several months.

Sightings of UFOs in Alabama are reported in newspapers periodically. Here are a few:

- In September 1973, UFOs were spotted in five east central Alabama towns as well as in Georgia, Tennessee and Florida. A story in the *Bangor Daily News* in Maine stated: "Officer Keith Broach of Auburn, Ala., said he saw something the size of an airplane, which appeared red and white, changed to green and then to white. A policeman in Lanett, Ala., said he saw an object about the size of a car." The sightings were not explained by weather balloons or other craft.
- In the summer of 1977, Mr. and Mrs. Terry White were driving home to Blount County with their small child in the car when they saw a strange object in the sky. As the couple stopped to watch, a bluish-gray light came on from the center of the object, which had a "geometric shape," according to a story in the February 19, 1978 edition of the *Tuscaloosa News*. Terry estimated the object to be sixty-five feet long. "No sound broke the summer night air, but they watched as

the object 'moved like a bullet' in a northerly direction, then stopped again." The couple continued driving and reached their mobile home, where they spotted a second, larger object high in the sky.
- In November 1977, Stewart Lewis of Tuscaloosa reported another strange object at Moundsville. "It was kind of a triangular shaped object with the shape of a pool rack. It had a deep yellow glow. It seemed like it was thrown out of an explosion. It was tumbling but was moving slowly on a line."
- In February 1993, the *Times Daily* in Florence reported a series of sightings in DeKalb County. Sue Johnson said, "It was bigger than an automobile and it was thicker in the middle than it was on the ends." Others who reported seeing the strange object to state troopers were Karen Twilley, Susanne Austin and Ernest G. "Gene" Moody, both of Geraldine. Sergeant Ron Ogletree stated, "We are treating all of them seriously because these are serious people. They are not publicity seekers who made all this up to get their name in the papers."

TAKE COVER AT THE BAT CAVE

When you think of bats, do you think of Count Dracula swinging his black cape across his face and mysteriously

transforming? The name "vampire bat" and the fact that bats are nocturnal creatures caused people to fear and misunderstand bats for decades. Some myths about bats include the ideas that they are blind, dirty, bloodsucking or harboring more rabies than other wildlife. Until recently, bats have remained dark mysteries.

In 1959, gray bats were being killed by the hundreds by human predators. The bats were nearing extinction until conservation programs were developed. Though still endangered, gray bats are thriving in Alabama.

Now, thousands of visitors come to Scottsboro each year to witness the emergence of the largest known summer colony of gray bats. Visitors stand on a balcony at the entrance of Sauta Cave from May to September to watch as more than 250,000 of the creatures fly into the night sky. The largest emergences occur in mid-summer. Entrances to the cave are closed to the public to protect the bats.

The "show" lasts thirty to forty minutes, and officials with Sauta Cave National Wildlife Refuge recommend wearing hats to protect heads from any droppings.

The 264-acre Sauta Cave National Wildlife Refuge was purchased in 1978 for the purpose of saving the gray bat colony, as well as a colony of Indiana bats. In summer, as many as 300,000 gray bats roost in the cave and then hibernate in winter.

The cave, once known as Blowing Wind, was used as a saltpeter mine during the Civil War, a Prohibition-era nightclub in the 1920s and a fallout shelter in the 1960s.

Sauta Cave Refuge is located seven miles west of Scottsboro off U.S. Highway 72. For more information, contact Wheeler National Wildlife Refuge at (256) 353-7243 or visit www.fws.gov/sautacave.

While Sauta offers a view of the largest emergence of bats, impressive viewing can be found at several other caves across the state. (Keep in mind that while public viewing is allowed, no admittance is allowed in the caves listed below, with the exception of Cathedral Caverns.)

Curious Creatures and Odd Occurrences

- Hambrick Cave. This Tennessee Valley Authority–owned cave is in Marshall County on the Tennessee River. It is home to one of the largest nursery colonies of gray bats. Emergences can exceed sixty thousand bats on summer evenings. Here, viewing is done from a boat anchored along the river.
- Nickajack Cave. To access this area, go to the TVA boat launch off Tennessee Highway 156. The cave is located .4 miles north of the Alabama-Tennessee state line. Visitors can view emergences of more than sixty thousand gray bats from an observation platform by the cave entrance or by boat from the Tennessee River.
- Cave Springs Cave. In late summer at this cave in Wheeler National Wildlife Refuge in Morgan County, as many as forty thousand gray bats can be seen during an emergence.
- Blowing Spring Cave Preserve. This small cave in Lauderdale County is managed by the Alabama Department of Conservation and Natural Resources. In summer, eight to ten thousand gray bats can be seen emerging each evening at dusk.
- Cathedral Caverns State Park. At this park near Grant, visitors can view a variety of cave formations as well as eastern pipistrelle bats in winter and big brown bats year round. Guided tours are available. The cave is open to the public.

When Bigfoot Stalked Coaling

In July 1978, two young couples were walking near a swampy area in the small community of Coaling in western Alabama when they spotted something unusual: tracks made by a three-toed creature. Could Bigfoot have visited Coaling?

The couples contacted Dr. Kenneth Turner, an anthropologist with the University of Alabama, to come investigate the tracks. Coaling, a town of about one thousand residents, is in Tuscaloosa County.

Turner brought his wife and father-in-law, who also was an anthropology professor, to the site, where they made plaster casts and measurements. Within two days, stories flew through the small town that a nine-foot hairy beast, or Bigfoot, had been spotted in their midst.

Turner, however, determined the prints to be a prank. The thirty-one tracks showed that whatever made them had double-arched feet, a human trait, and the prints appeared at varied distances apart, and in one case were six feet apart. Turner said the creature could not have jumped that six-foot length because the prints were all of equal depth.

In addition, this area of the state is largely agricultural, and most Bigfoot sightings are reported in heavily wooded areas. The prank and its investigation were reported July 13 in the *Tuscaloosa News*, ending speculation in that case but not Alabamians' interest in the mythical creature.

What Is That Red-Eyed Creature?

Did you know that the legend of the Mothman that developed in Point Pleasant, West Virginia, and was the subject of newspaper articles for months in 1966 and 1967 has a connection to Alabama? At least some theorists say it's true.

Mothman was mostly described as a creature the size of a human with glowing red eyes and wings like those of a moth. Some said the creature seemed to have no head and had eyes set in its chest. People also described the strange shriek made by the Mothman. The legend of the Mothman is recounted in many books, the most recognizable of which is *The Mothman Prophecies* by John Keel, on which the 2002 film of the same name starring Richard Gere was based.

Keel linked the appearance of the Mothman creature to the December 15, 1967 collapse of the Silver Bridge, which spanned the Ohio River. Forty-six people died in the collapse.

Some paranormal enthusiasts claim that a 1948 sighting of unusual creatures in Selma may be a link to Mothman. But this link comes through another legendary creature: the gargoyle.

While most know gargoyles as architectural elements in the form of grotesque creatures that were used to convey rainwater away from a building to protect the mortar, some believe these statues are based on real creatures. According to legend, a creature called La Gargouille terrorized

residents of a village in France in the seventh century. It looked like a dragon with bat-like wings and a long neck, and it spewed fire from its mouth.

In the summer of 1948, a Selma resident attending a family reunion picnic reportedly saw a gargoyle-like creature land near a tree. He noticed it had a human form and stared at him with red eyes. He alerted the others, who watched the creature until it flew away. On its heels came reports of more gargoyle sightings in the area. They were described as birdlike creatures with red eyes that swooped down and picked up small animals. Was Mothman a gargoyle?

While no other sightings of gargoyles or huge birdlike creatures have been recorded in Alabama, one witness reported on a paranormal website that he saw a reptilian creature near the Elk River in Limestone County. The incident occurred just west of Interstate 65 and south of the Tennessee line and was reportedly confirmed by a team of paranormal investigators from New England. It walked upright, like a humanoid lizard.

Was it human? Reptilian? Alien? We will likely never know.

THE MYSTERY MAN BEHIND HEAVEN'S GATE

In 1961, a handsome and charming man came to the University of Alabama's music department to teach chorale

students. He made friends who described him as "affable," and he was well liked by students. In 1964, he left the university for another position and was described by a co-worker in a 1975 article in the *Tuscaloosa News*: "Herff was a person with a lot of personal appeal," said Dr. Wilbur Rowan.

Rowan was interviewed about his former colleague, Marshall Herff Applewhite, after Applewhite became the leader of a cult in the early 1970s and convinced a group of believers in Oregon to follow him into the Colorado desert in 1975 to await the arrival of a UFO that would take away the chosen ones.

Applewhite, who by that time was using his first name, met Bonnie Lu Trousdale Nettles around 1970, and it was apparently her belief in "salvation by spaceship" that swayed Applewhite to form the group that eventually would become known as Heaven's Gate. His apparent shift in personality was blamed by some on his 1968 divorce.

Nettles and Applewhite convinced themselves that they were "The Two" referred to in Revelations. Thinking earthly laws did not apply to them, they committed credit card theft, and Applewhite spent some time in jail, where he formulated his UFO theory.

When no spaceship arrived in 1975, the group remained out of the limelight for years before resurfacing in the early 1990s. Over the years, the group went by the name Human Individual Metamorphosis and Total Overcomers Anonymous.

Nettles died of cancer in 1985, but Applewhite recovered sufficiently to continue their mission. In 1997, as the Hale-

Bopp comet approached, he saw it as a sign that it was time to go to the Next Level. That March, he and thirty-eight of his followers, all dressed in purple robes, drank a concoction of vodka and barbiturates. Their bodies were discovered on March 26 at their compound in Rancho Santa Fe, California. One of the suicide victims was the brother of Nichele Nichols, the actress who played Lieutenant Uhura on *Star Trek*.

THE BATTLE OF MONSTER HOGS

The battle of Hogzilla, Monster Pig and Hog Kong may sound like a Japanese monster film, but this contest is all too real. Well, mostly.

On May 4, 2007, the Associated Press sent a story across the news wires detailing an unusual occurrence near

Anniston the previous day: an eleven-year-old boy was credited with killing one of the largest wild pigs on record, a massive 1,051-pound creature.

The AP reported that young Jamison Stone killed the nine-foot-, four-inch-long monster pig with a pistol, beating out the record 2004 kill of Hogzilla, a wild hog reported to weigh more than one thousand pounds and being twelve feet long. The massive Hogzilla was shot by Chris Griffin on Ken Holyoak's fish farm and hunting reserve in Alapaha, Georgia.

The legend grew until, in November, the town of Alapaha held a Hogzilla parade and beauty pageant (although why anyone would claim the title Miss Hogzilla was never explained). Photos of Hogzilla circulated on the Internet, and the legend of Hogzilla was thought by some to be a hoax. However, a group of scientists who gathered to film a National Geographic television show in 2005 exhumed Hogzilla's remains and determined its dimensions to be exaggerated but still quite large. In life, Hogzilla would have been about seven or eight feet in length and weighed eight hundred pounds. Tests on the creature's DNA showed that he was a hybrid of a wild boar and Hampshire breed domestic pig. One of his tusks measured more than two feet in length, while the other was about nineteen inches.

So Hogzilla was of large—but no longer legendary—proportions. Here's where the contest begins.

In August 2004, Larry Earley shot and killed a wild hog dubbed Hog Kong, which weighed an estimated 1,140 pounds. No scales were available to weigh the creature,

but several witnesses, including a local meat processor, said Hog Kong must have weighed more than 1,000 pounds.

Earley shot the hog at his twenty-two-acre farm near Leesburg, Florida. He later had the head mounted, no small job since the hog's neck was forty-two inches in diameter.

In January 2007, Bill Coursey of Georgia shot and killed a nine-foot, 1,100-pound hog in Fayette County and hung it from a tree in his yard for passersby to see. Witnesses said the huge animal had been spotted for several days in the neighborhood before it was killed. Coursey believed the animal to be a feral hog, which are not uncommon in southern Georgia, but fieldandstream.com reported in March 2007 that Coursey's hog may have been an escaped domestic pig.

The most controversial entry into the foray—and the only one from Alabama—was the kill of the Monster Pig in May 2007 by young Jamison Stone of Pickensville. The creature was so huge that trees had to be cut and a backhoe brought into the woods to remove its carcass. It was taken by truck to the Clay County Farmers Exchange, where it was weighed. The scales gave weight in 10-pound increments, so some thought the claim of 1,051 pounds was suspect, but one onlooker explained that when the scale went one notch past 1,050, they thought it meant one additional pound. They believe Monster Pig likely weighed 1,060 pounds.

Jamison and his father, Mike, had gone to the 2,500-acre Lost Creek Plantation commercial preserve for a wild game hunt and reportedly made the kill in good faith. But, as the world and the Associated Press would later learn, Monster Pig

was actually a domesticated pig named Fred that had been raised on a nearby farm. Domestic pigs can reach more than one thousand pounds, with the largest recorded weighing more than two thousand pounds. Fred had been a Christmas gift from farmer Phil Blissitt to his wife, Rhonda, in 2004. The pig grew to his astounding size by dining on treats such as canned sweet potatoes. The Blissitts had recently decided to sell their stock of pigs and sold Fred to Lost Creek Plantation four days before he died, knowing he would likely be hunted.

The Stones, though, stated that they were told they by the preserve's owners that they were hunting feral hogs. No one was ever charged with creating a hoax or of illegal activity, but the preserve later closed.

What is the legacy of the great pig wars? The story of Hogzilla was to have been caught on film. Two movies were planned—*Hogzilla: The Other White Meat Bites Back* and *The Legend of Hogzilla*—but they apparently never made it to the big screen.

Still, this is one legend that has legs…you probably haven't heard the last of the gigantic hogs.

Watch Out for Huggin' Molly

For mothers wanting their children to hurry home at dark, Molly was a helper. For children, she was downright frightening.

The Abbeville legend of Huggin' Molly began decades ago. Legend claims that a phantom woman would appear to children, but only at night. She would squeeze them tightly and then scream in their ears. She never harmed them, other than perhaps causing some ringing in their ears. The figure was as much as seven feet tall, wearing dark clothing and a wide-brimmed hat.

One version of the story claims that Molly was the ghost of a woman who had lost an infant who dealt with the tragedy by hugging local children. Another states that Molly was a professor at the former Southeast Alabama Agriculture School who was trying to keep students safe by keeping them off the streets at night.

The woman, whose last name is unknown, is rumored to be buried in Abbeville's Old Cemetery.

Tales of Huggin' Molly also can be found in Louisiana and Florida. While Florida's story is similar to the one in Abbeville, Louisiana's is quite different. In the 1965 book *Gumbo Ya-Ya: Folk Tales of Louisiana*, by Lyle Saxon, Edward Dreyer and Robert Tallant, the authors state that Huggin' Molly was a mentally disturbed man who grabbed the women of Baton Rouge at night. For whatever reason, perhaps anonymity, he was said to wear a white sheet, causing some black women to fear that he was a member of the Ku Klux Klan. The male Huggin' Molly also never hurt his victims.

Today, Abbeville residents remember Huggin' Molly by venturing downtown and stopping in a café named for

the phantom. Huggin' Molly's is set in an old pharmacy, complete with a soda fountain, and offers such treats as "sandwitches" and "Molly fingers." Huggin' Molly's is located at 129 Kirkland Street in Abbeville.

The Endangered Rattlesnake Rodeo

The Rattlesnake Rodeo in Opp is a cringe-worthy event but one that has stood the test of time. As many as twenty-five thousand people attended the event in the tiny southern Alabama town in March 2010.

During the two-day "rodeo," hunters head into the woods searching for the holes in the ground where the snakes live and bring them back, still alive, to be displayed. Dozens are caught. Spectators watch the hunters handle the deadly snakes, learn about rattlesnakes and perhaps have a rattlesnack—fried snake meat sandwiches are sold for five dollars. Later, the snakes' hides are sold, and the dried heads and rattlers become souvenirs.

Now, after fifty years, the tradition of rounding up these poisonous snakes is threatened. Reptile experts oppose the event, saying it and similar events in other states have endangered eastern diamondback rattlesnakes.

Only time will show if the Opp Rattlesnake Rodeo survives.

Do Spirits Lurk at St. James Hotel?

Visitors to Selma walking along Water Avenue and gazing up at the wrought-iron-railed balconies of the St. James Hotel may, for a moment, think they are in New Orleans. The beautifully restored 1837 inn overlooking the Alabama River is one of the state's oldest hotels. As such, it is the subject of dozens of dramatic tales. As with all historic sites, some of these stories feature dead people—only some claim they can still see the dead people of the St. James.

The hotel has been investigated by paranormal experts and is listed on many websites about haunted places. The hotel opened as the Brantley Hotel, a destination for businessmen, cotton merchants and other travelers. But following the Battle of Selma on April 2, 1865, the hotel was a base of operations for Union troops, which is one reason it survived when much of the city was destroyed.

While owner Dr. James Gee was away during and after the Civil War, he entrusted his former slave, Benjamin Sterling Turner, to run the hotel. Turner, who owned a livery stable, later became the first African American elected to the United States Congress.

In 1881, notorious outlaws Frank and Jesse James reportedly stayed at the hotel under an alias. Legend also says that a beautiful dark-haired woman named Lucinda, a longtime resident of the hotel, was Jesse James's girlfriend. A portrait of her hangs over the fireplace in the great room of the hotel.

Curious Creatures and Odd Occurrences

Visitors to the hotel claim to have seen apparitions of Jesse and Lucinda. Lucinda's spirit is said to haunt one of the rooms in the historic section of the hotel and to walk the hallways. A male spirit with jangling spurs, thought to be the ghost of Jesse James, has been seen sitting at a table in the drinking room.

The spirit of a dog also has been heard barking but has not been seen.

General phenomena include the appearance of groups of apparitions dressed in 1880s garb in the inner courtyard, the sounds of clinking glassware at the bar and flashes of light in room 304. The hotel was renamed the St. James following the war and maintained its reputation as a fine inn for many years until the Hotel Albert opened and took some of its business.

In 1892, the hotel closed. Over the next decades, the building was used for a variety of commercial and industrial purposes and fell into ruin.

Residents of Selma would not let the old hotel die. In 1997, it reopened, newly refurbished, as a hotel with a restaurant, drinking room, ballrooms and a view of the Alabama River. For more information, visit historichotels.com or call (334) 872-3234 or the toll-free reservations line (800) 678-8946.

Rena Teel's Sixth Sense

When Irene "Rena" Vanzandt Teel was born on April 8, 1894, near Rockford, midwife Edna Sandling knew the infant was destined for a special life. She was born with a caul, commonly referred to as a "veil over the face," which lore told meant she would have a sixth sense.

In Rena's case, this sense allowed her to find lost objects, locate missing people and sometimes know the outcomes of crimes. According to some reports, Rena predicted the death of her baby brother, who had been healthy. She grew to consider her abilities as a divine gift.

In 1912, she married Benjamin Riley Teel and moved to Millerville in Clay County, where she continued aiding townspeople with her predictions. By then, her reputation had grown until people from across the state and Southeast would make trips to see her.

According to renowned Alabama author Kathryn Tucker Windham in her book *Alabama: One Big Front Porch*, Teel read coffee grounds. Windham recounts a tale in which Teel tried to stop a hanging, saying the man accused in a young girl's murder was innocent and she had foreseen the real killer would come forward in two years. Her words fell on deaf ears. The man was executed.

Two years later, another man confessed to the murder.

Another story, though, states that Rena was able to prevent a murder with her vision.

Most of her readings involved less dramatic work. She would help clients find lost people or items and tell engaged young women what kinds of men they were about to marry.

She died May 14, 1964, in Millerville.

JUST WHAT IS THE WHITE THING?

On a summer evening in 2006, a young girl looked out the bedroom window of her Morgan County home and was shocked to see a white figure. Could it be a bear?

She looked more closely at the figure, which was visible in the light from the porch. When the figure suddenly stood upright, the girl gasped. It was as much as seven feet tall and covered in hair. It was solid white.

The legend of the Alabama White Thing has been prevalent since the 1940s in the triangle between Morgan, Etowah and Jefferson Counties.

It has been sighted in Happy Hollow, Walnut Grove, Moody's Chapel and Wheeler Wildlife Refuge. The creature is known for its ability to move extremely quickly, despite its size, and for its eerie screech that sounds like a woman's scream. Some have described the scream as sounding like that of a panther. Many have speculated that the White Thing is an albino Bigfoot or perhaps a large albino bear.

But in Huntsville, the Alabama White Thing is used to describe a humanoid, possibly alien figure spotted in caves

or drainage ditches in Jones Valley, along Governor's Drive and on Monte Sano Mountain. The creature is described as having no eyes or ears and being completely white. A team of researchers of the White Thing started a Facebook page called Alabama White Thang.

Its creators ask for anyone who has seen the White Thing to send in accounts and descriptions to further their desire for a more in-depth investigation. "Any evidence would be extremely helpful," they write. "Possibly photos or material evidence would make this worth a greater look to the news."

MISS BAKER'S FINAL FRONTIER

In the 1970s and 1980s, children from across the country came to the U.S. Space and Rocket Center in Huntsville, Alabama, with one purpose in mind: seeing an actual "monkeynaut." The famed astronaut monkey named Miss Baker resided at the Space Center in a specially made habitat known as the monkeynaut chamber.

Miss Baker, a squirrel monkey, rode into space on May 28, 1959, with Able, a seven-pound rhesus monkey. They were launched from Cape Canaveral, Florida, and rode in the cone of a Jupiter missile three hundred miles into space before returning safely to the earth sixteen minutes later. They were the first mammals to survive a trip into space and withstood forces of thirty-eight times the pull of gravity on earth.

Upon her return, Miss Baker was given a banana and a cracker, which she ate and promptly took a nap.

The monkeys became international celebrities after their flight, appearing in numerous magazines, including on the cover of *Life*. Their journey paved the way for human space travel.

Able died a few days after the launch during surgery to remove her electrodes. She is honored with a marker in Independence, Kansas, where she was born.

Miss Baker weighed only eleven ounces during her trip into space. She resided for twelve years at Naval Aerospace Medical Center in Pensacola, Florida, before Ed Buckbee,

who was at the time director of the Space Center in Huntsville, requested the monkey come to live in the city where the Jupiter was built.

A special temperature- and humidity-controlled habitat was built for Miss Baker, with part covered in a clear dome so that she could interact with people who visited the space museum. She received fan mail, and her birthdays, celebrated with cakes of Jell-o and fruit, were covered by the media.

Her mate, Big George, whom Miss Baker had "married" in a ceremony while still in Florida in 1962, came with her to Huntsville. After his death, Miss Baker had another mate, Norman.

Miss Baker developed kidney disease and died on November 29, 1984, at the age of twenty-seven. At the time, she was believed to be the longest-living documented squirrel monkey.

She is buried near the entrance of the U.S. Space & Rocket Center next to her two "husbands." Children attending Space Camp often leave bananas on her grave marker.

In 2006, Miss Baker was inducted into the Alabama Animal Hall of Fame.

About the Author

Kelly Kazek is managing editor of the *News Courier* in Athens, Alabama. In her more than two decades as a journalist, she has won more than 125 national and state press awards. She is the author of three other books: *Fairly Odd Mother: Musings of a Slightly Off Southern Mom*, a collection of her syndicated humor columns; *A History of Alabama's Deadliest Tornadoes: Disaster in Dixie*; and *Images of America: Athens and Limestone County*. She lives in Madison, Alabama, with her daughter, Shannon, their beagle, Lucy, and cats Mad Max, Luvey and Charley.

Visit us at
www.historypress.net

This title is also available as an e-book